CHEROKEE
POTTERY

CHEROKEE POTTERY

From the Hands of our Elders

M. ANNA FARIELLO

Introduction by Jane Eastman

Charleston — London

THE
History
PRESS

Published by The History Press
Charleston, SC 29403
www.historypress.net

First published 2011

Manufactured in the United States

ISBN 978.1.60949.057.7

Library of Congress Cataloging-in-Publication Data

Fariello, M. Anna.
Cherokee pottery : from the hands of our elders / M. Anna Fariello ; introduction by Jane
Eastman.
p. cm.
Includes bibliographical references.
ISBN 978-1-60949-057-7
1. Cherokee pottery--History. 2. Cherokee Indians--History. 3. Cherokee Indians--Social
life and customs. I. Title.
E99.C5F38 2011
975.004'97557--dc22
2011004524

CONTENTS

CONTENTS

FOREWORD

By Tonya Carroll

This book is dedicated to all Cherokee people; past, present and future. The purpose of this book is to document the work of the potters of the Eastern Band of Cherokee Indians that were crucial to keeping this art form alive for future Cherokee artists during the early to mid-twentieth century. The significance of this book is that it honors these potters for their contributions to our tribe. As Cherokees, we have a long history, and it is our responsibility to learn that history and use it to keep our traditions and culture alive. We are a blessed nation because our ancestors knew the importance of preserving our heritage, and it is shown in this book through the lives of our artists. The first edition of *From the Hands of our Elders* books, *Cherokee Basketry*, honored the lives and skills of our Cherokee basket makers during the same time period. This book will hopefully create the same impact as the former by reviving designs or techniques, sparking interest in the art form, inspiring our artists to continue creating magnificent art and keeping the memory of these important Cherokee tradition bearers alive.

If it were not for our artists, much of our culture would be lost. Much of what we know today about our past is learned through the artwork that still exists, because when people create, they put a part of themselves in their work. From their artwork, we can learn important information about our ancestors, such as what materials were native in Cherokee territory, who the Cherokee people had contact with and what they were obtaining through trade. We can learn what was popular within our tribe during different time periods based on the abundance or lack of certain objects. Most importantly,

we learn about the people who made the artwork, and this allows us to teach our own people what it is to be Cherokee. As the saying goes, "knowledge is power," and we as Cherokees are our strongest when we are living as Cherokees. This means participating in dances and ceremonies, speaking our language and learning our traditional arts and crafts. The artists in this book knew that, and through their work, this important lesson is being passed down in our tribe through our families, in our school system and now through this book. Even though the artists in this book may not have made it into our school textbooks, they are important. They are the people that kept our arts and crafts alive. This book recognizes and honors their efforts and accomplishments.

Elected as Miss Cherokee 2010, Tonya Carroll is a graduate of Western Carolina University with bachelor's and master's of arts in history and Cherokee studies. She is currently outreach coordinator for Qualla Arts and Crafts Mutual, Inc.

PREFACE

The generation documented in *Cherokee Pottery: From the Hands of our Elders* includes those potters whose work spanned the turn of the twentieth century. This was a period of transition, from a point when pottery was produced for home use to its status as an object collected and admired. As an outsider, I am struck by the continuity of this tradition, supported by the strength of family and community. As a curator, I am impressed by the adaptations and inventiveness demonstrated by a generation whose lives were constantly shifting in response to changes brought about by outside forces. *Cherokee Pottery* is part of a larger project, *From the Hands of our Elders*. This work sprang from a desire to share exceptional work by, and photographs of, a particular generation of Cherokee artists with the Cherokee community and beyond. This generation of artists and craftsmen shaped Cherokee's contemporary aesthetic and inspired others to follow their creative lead. The first book in this series examined Cherokee basketry, revealing the craft's forms, functions and methods and recording the tradition's celebrated makers; this book hopes to meet those same goals.

This book had its start as a documentary project sponsored by a number of regional institutions. Primary support came from Western Carolina University's Hunter Library and the Cherokee Preservation Foundation. Through projects such as this one, the Hunter Library is assembling a series of historically significant digital collections and building community through its collaboration with regional partners. In the words of Dana M. Sally, dean of Library Services, "We are committed to developing greater understandings

of, and creating new contexts for, these extraordinary collections, with the specific intent of enhancing their meaning." To bring this story to light, the library collaborated with two of the Cherokees' primary cultural institutions, Qualla Arts and Crafts Mutual, Inc. and the Museum of the Cherokee Indian. Under its program of cultural preservation, the Cherokee Preservation Foundation contributed funding to its success.

Contributions to *Cherokee Pottery* were made by a number of people. In particular, the efforts of Qualla Arts and Crafts manager Vicki Cruz and outreach coordinator Tonya Carroll have helped to make this book a meaningful resource for future study. Jane Eastman contributed an introduction that provides the archaeological context that sets the stage for our contemporary understanding. Jason Wolf tracked down endless articles, documents, photographs and permissions in his role as research assistant at Hunter Library. Lucas Rogers photographed the entire permanent collection housed at Qualla Arts and completed the initial documentation on all of the objects that he photographed. His images fill the pages of this book. Budget operations manager Margaret Watson kept an eye on the project's funds, meeting state and grant deadlines with a calm determination. A special thank-you goes to those who were generous with their time, answering questions and helping to verify factual information: Roseanna Belt, Tom Belt, Andrew Denson, Jane Eastman, Hartwell Francis, George Frizzell and Lisa Lefler. Special thanks to Catawba scholar Thomas J. Blumer and Brent Burgin, archivist of the Blumer Collection at the University of South Carolina–Lancaster, for their assistance in providing images and factual information for the chapter on Catawba potters. More than any, I thank the many families who took the time to help check dates and the spelling of names so that this book can properly honor the memory of their ancestors. While the project team worked hand in hand with local people, Dr. Sally reminded us of our larger objective, "This is a human story, and a story of national cultural significance."

Several institutions contributed images to this book, adding to the richness of the pages to follow. These include Berea College, Cherokee Heritage Center, Great Smoky Mountains National Park, Hunter Library's Special Collections, Museum of the Cherokee Indian, Museum of the Red River, National Archives and Records Administration, North Carolina Arts Council, North Carolina Folklife Institute, North Carolina State Archives, Qualla Arts and Crafts Mutual, Southern Highland Craft Guild, University of North Carolina–Chapel Hill, University of South Carolina–Lancaster and Western Carolina University's Mountain Heritage Center.

While we hope that this book will have meaning in the future as a historical document, it looks to the past to explore the roots of tradition. Jane Eastman's introduction considers pottery made by unnamed artisans working during the Qualla phase of archaeological prehistory. The opening chapter recounts the first historic references to Cherokee pottery and provides an overview of Eastern Band Cherokees and a region rich with natural wealth. Careful examination is given to visits made by nineteenth-century ethnographers James Mooney and M.R. Harrington, who spent time with potters on the Qualla Boundary. Through them, we meet potters caught in the moment, Uhyuni, Sallie Wahuhu and Jennie Arch, who, in the eyes of these ethnologists, have neither a past nor a future. We meet Susannah and Nettie Owl, a pair of Catawba potters who, married to Cherokee men, worked within a circle of accomplished Cherokee potters: Lillie Bryson, Rebecca Youngbird and Maude Welch. We learn about homegrown pottery methods and forms through Katalsta and her daughter, Iwi Katalsta, following them into the twentieth century. We are still a half century back from our own time when we witness changes brought about by increasing tourism and the formation of the Cherokees' own artisan guild. There we meet the rest of the elders chronicled in this book: the Bigmeat family, Cora Wahnetah, Edith Bradley and Amanda Swimmer. It is the responsibility of the current generation to take advantage of the time we have, time to capture stories before they are lost and time to locate images before they are tossed out by the unsuspecting. I am proud to have been a part of this effort.

Anna Fariello

ꭱꮐꭵꭽꮻꭵ Ꮏꮤꭶꮊꭵ

Elohi Utseli Iyadvti

Earth its to.do

Traditions of the Earth

Introduction by Jane Eastman

If one considers early pottery making from a global perspective, it was very much associated with humans settling down and making a commitment to life in a community rather than moving frequently between temporary camps. These more stable communities were usually located in areas with diverse or very rich resources capable of sustaining people over seasons or even year round. With the advent and intensification of farming around the world, permanent settlements became more common as did pottery.[1] Early pottery making is almost always focused on providing durable containers that can withstand cooking and serving countless meals and for storing food and liquids for later consumption. In this way, the act of creating pottery can be seen as physical proof of a people's commitment to a homeland and specifically to a home community. It simply is not feasible to create pottery if you are highly mobile, especially when baskets or containers of animal hide or bladders, bark, textiles or gourds are lighter and less likely to break in transport. No, pottery is best suited for long-term use within a community and was probably most often used by a single household. Because high-quality clays are widely available and because most people can attain the skills needed to produce serviceable pots, each household, typically women of the household, would make the pots they required for daily use. From this perspective, hand-built pottery not only was made of earth, but it was of a particular place. It was made by people who had put down roots and who themselves were of that place.

Left: This rendering of a Native American cooking pot was made during John White's voyage to North Carolina's Outer Banks. He marked the image with this notation: "The seething of their meate in Potts of earth." *Watercolor painting by John White, 1585.*

Opposite: 1900 map of the eastern United States by ethnographer James Mooney indicating territory held by the Cherokee at various times. *Hunter Library Special Collections, Western Carolina University.*

Because pottery is an additive technology, meaning that raw materials are brought together to build up a pot, the form and decoration of pottery vessels can be quite variable and are determined more by the imagination and skill of the potter than by the physical qualities of the raw materials. The properties of clay can be altered by mixing different clays together and by adding other materials to the clay to form a ceramic paste with the desired properties. Also, the malleable nature of the clay and prepared ceramic paste allows a skilled potter a high degree of freedom to create the vessel they envision. In this manner, pottery vessels can be crafted to meet the specific cooking or storage needs of a household and also to satisfy the aesthetic tastes of the potter. Similarly, design elements can be tailored to express information about the identity or worldview of the potter. As one generation of potters teaches another to make the pots needed for their own unique cookery and to satisfy their ritual needs, traditions and distinctive styles develop and are passed on within groups of related potters. The characteristics of pottery vessels often become recognizable markers of cultural identity and an expression of a unique cultural worldview.

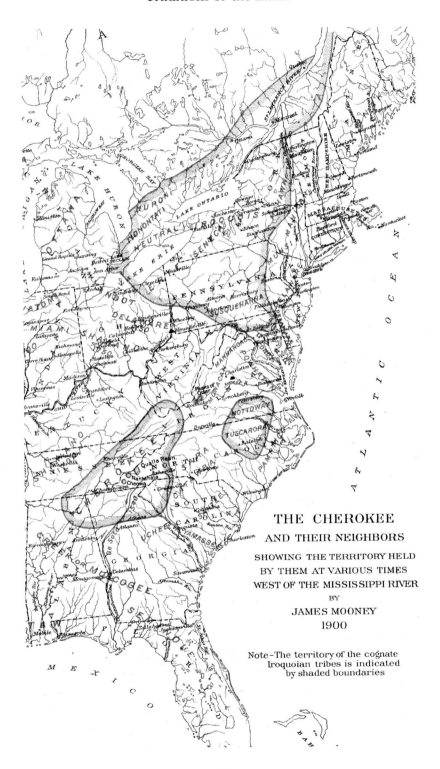

THE CHEROKEE

AND THEIR NEIGHBORS

SHOWING THE TERRITORY HELD
BY THEM AT VARIOUS TIMES
WEST OF THE MISSISSIPPI RIVER

BY

JAMES MOONEY
1900

Note–The territory of the cognate
Iroquoian tribes is indicated
by shaded boundaries

TRADITIONAL TERRITORY

In the eighteenth century, the Cherokee claimed a territory that today comprises parts of eight states—North and South Carolina, Georgia, Alabama, Tennessee, Virginia, West Virginia and Kentucky—an area of more than 140,000 square miles. This included all areas indicated on a 1900 map drawn by ethnologist James Mooney, plus adjacent territory stretching to the west incorporating all of Kentucky, Tennessee and the northern portion of Alabama. Even the heartland of Cherokee territory as indicated in the Mooney map encompasses a wide variety of physiographic and environmental zones. These include the Valley and Ridge Province in eastern Tennessee, the rugged Blue Ridge of southwestern North Carolina and the upper Piedmont of South Carolina and Georgia. At that time, villages were referenced by their location within one of five town areas: Lower towns in the upper Piedmont; Middle, Out and Valley in the Blue Ridge; and Overhill in the Valley and Ridge Province. The sacred Mother Town of Kituwah, where the Cherokee language and way of life came to be, was one of the Out Towns, situated near present-day Bryson City, North Carolina. Mooney reported that three dialects of Cherokee were spoken in the town areas: Kituhwa in the Middle and Out Towns, Elati in the Lower Towns and Otali in the Overhill and Valley Towns.[2] These dialects are still spoken today in different Cherokee communities.

Locations of many other Cherokee towns in this territory are remembered, known from historic documents, or have been identified archaeologically. With the ravages of disease, treaty cessions and forced relocation and removal, the Eastern Band of Cherokee retain only a small fraction of these ancestral lands but have begun to reclaim some of their most important ancient town sites. Large parcels of land around the former towns of Kituhwa and Cowee have been purchased by the Eastern Band in recent years and are once again within Cherokee territory.[3]

Two distinctive traditions of pottery making were known to have been made by Cherokee potters in the centuries prior to and after contact with Europeans. Interestingly, these different pottery-making areas do not correspond to the distribution of different dialects. Archaeologists have classified the pottery from Middle, Out and Valley Towns in western North Carolina as the Qualla series. Very similar pottery from Lower Towns in South Carolina and Georgia has been classified into two chronologically distinct series, Tugalo and Estatoe. A technologically and stylistically distinctive kind of pottery, identified as the Overhill series, was made by

Cherokees living in the Valley and Ridge Province of eastern Tennessee. Because this book focuses on potters of the Eastern Band of Cherokee Indians, and because of the brevity of this introduction, discussion will focus on the wares of Cherokee potters and their ancestors who committed to life in the southern Appalachians.

LIFE IN APPALACHIA

Native people first began living in eastern North America before the end of the Great Ice Age and have lived here continuously for over twelve thousand years.[4] Human adaptations to the southern Appalachians have changed in harmony with changes in climate and flora and fauna that people depended on for food and raw materials. The founding populations were small and consisted of mobile hunters and gatherers. Over the millennia, technological innovations were made, and some native plants like gourds and squash, which had long been gathered for food, became domesticated. Horticulture was added to the foraging subsistence strategies in the region. Plants from other regions, such as sunflowers, were adopted, and in the last two millennia, farming of very productive plants like maize and beans was also adopted and became the cornerstone of Cherokee diet. Maize, beans and squash, often referred to as the Three Sisters, formed the basis of their foodways, but hunting, fishing and gathering nuts and other wild plants continued to contribute significantly to Cherokee diet.

Cherokee men and women cleared fields for farming, fruit and nut trees were managed to increase their productivity and weirs and fish traps aided in harvesting fish from rivers. Species diversity was encouraged along the edges of forests and within them through periodic burning. An annual cycle of subsistence activities and complementary contributions from men and women, adults and children provided a stable and sustainable way of life for generations of Cherokee peoples stretching back into time immemorial.

Populations in the region increased over time, and larger and longer-term communities emerged. With maize-based agriculture, permanent towns were established with more complex political structures than had been required in earlier eras. In the centuries following AD 1000, some areas of Cherokee territory were characterized by a chiefdom level of social organization in which a degree of social hierarchy was apparent. By the eighteenth century, Cherokee communities were more egalitarian, and leadership was divided among peace and war chiefs and heads of

matrilineages.[5] Some Cherokee towns, such as Kituhwa and Cowee, served as centers of regional interaction and trade. A dozen or so towns were present in each of the town areas in Cherokee territory, and these were linked by overland trails and via dugout canoes along the many rivers that bisected the valleys. At the time the first Europeans described the political organization of Cherokee territory, each town had its own leadership and could act independently of the leadership of other towns. However, Cherokees as a people were united by common cultural traditions, especially their language and oral history, and by shared symbols and ways of understanding their homeland and their place in the wider world.

Some of these shared symbols and ways of understanding were represented in the things the Cherokee made and used. Pottery vessels were often vehicles for expressing these beliefs and symbols. In the Qualla series, symbolically important geometric designs were stamped or engraved on the exterior of jars and bowls. In many cases, the ideas that potters integrated into their vessels—their worldview—cannot be interpreted clearly today and perhaps has been lost all together. Luckily, much of that uniquely Cherokee way of viewing the world has survived the tumult of the last several hundred years, and new generations of artists, authors and storytellers are continuing to imbue their Cherokee viewpoint into their creations.

It may be optimistic to believe that one could successfully bridge the temporal and cultural gaps that exist between us and a woman who fashioned Qualla style pots five centuries ago, but it seems worthwhile to contemplate the hands and mind of that potter. We can appreciate the choices that she made in the production of a pot that would not only function as intended, but also was capable of expressing more esoteric things about her understanding of the world and her imagination. Pottery can be viewed as a necessary aspect of cooking technology, and much can be learned about the cookery of its maker through studying a pot from this perspective. But as you read this short introduction and look at the illustrations of Cherokee pottery in this volume, take a moment to consider the stylistic aspects of the pot as well. Recognize that the particular shape of and specific decoration on a Qualla pot was not accidental, but rather these characteristics had evolved over hundreds of years to define a distinctively Cherokee way of making pottery that passed on through generations of women.

Appalachian Pottery of the Ancestors

Along the Atlantic coast of the southeastern United States, archaeologists have found pottery dating back 4,500 years, but pottery making did not develop that early in the interior of the continent. The beginnings of pottery making in the Cherokee homeland dates to between 2,500 and 3,000 years ago and probably is related to other similar traditions found along the Appalachians into the northeastern United States, rather than this earlier coastal tradition.[6] The first two thousand years of pottery making constitute what archaeologists call the Woodland Period (1000 BC–AD 1000). This early pottery in the southern Appalachians took the form of tall jars with conical bases and simple bowls. Over time, styles evolved, and archaeologists can recognize several distinctive Woodland pottery series in the Cherokee homeland.

The earliest style of pottery is known as the Swannanoa series, and it was manufactured between 1000 and 300 BC. Swannanoa vessels had thick walls, and the exterior surface of the pots was covered with impressions of cords and woven fabric. Crushed rock or coarse sand was added to the clay to form the ceramic paste. After 300 BC, as horticulture became more common during what archaeologists call the Middle Woodland period, changes in pottery making indicate influences from the south, most likely from central Georgia, began to affect pottery making in the region. Beginning with the Pigeon series, carved wooden paddles were used to stamp exterior surfaces of pots rather than textiles.[7] Although, as will be discussed below, the carved designs on the paddles would change over time, carved paddle stamping would become a hallmark of pottery making in the Appalachian summit area from this time through the end of the nineteenth century, roughly fifteen hundred years. The most common stamped design on Pigeon pottery is check stamping, which resembles crosshatching. By AD 300, influence from Hopewell peoples in the Ohio Valley was apparent at several sites in the Appalachian Summit.[8] Connestee pottery, manufactured in southwestern North Carolina, eastern Tennessee and northern Georgia at this time, was characterized by thin-walled vessels with exterior surfaces that were plain, brushed or stamped with paddles carved with simple parallel grooves. Connestee series pots were made until about AD 800. Both Pigeon and Connestee style jars sometimes have small triangular feet to help stabilize the pot while standing upright on a surface.

Few sites from the subsequent Late Woodland period are known from the Cherokee homeland. By AD 1000, maize-based agriculture supported a more

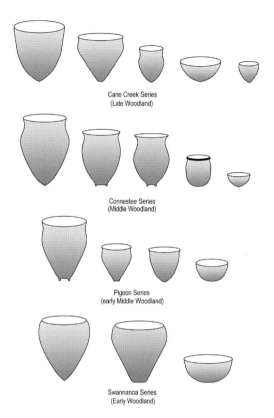

Cane Creek Series
(Late Woodland)

Connestee Series
(Middle Woodland)

Pigeon Series
(early Middle Woodland)

Swannanoa Series
(Early Woodland)

Basic vessel forms of Woodland Period pottery series manufactured in the Appalachian Summit. *Research Laboratories of Archaeology, University of North Carolina at Chapel Hill.*

complex way of life, referred to as South Appalachian Mississippian, which included communities with stockades. Their council houses and important residences were built on artificial earthen mounds to raise them above ground level. Though regional pottery traditions are apparent, archaeologists recognize that stylistic similarities characterized pottery made after AD 1000 throughout present-day South Carolina, across northern Georgia and Alabama, eastern Tennessee and western North Carolina. These similarities included complicated stamped exteriors, incised designs on the upper portion of bowls and sand or grit temper, and they are conceptualized as part of a widespread Lamar ceramic complex.[9] Pisgah pottery represents one of these regional Lamar variants that were most common in the eastern area of the Appalachian Summit, including the Oconaluftee, Tuckasegee, French Broad and Pigeon River Valleys. Pisgah pottery was made between AD 1000 and 1450 and was initially thought to represent the precursor to Qualla pottery.[10] Given that Qualla pottery is mostly found west and south of the area where Pisgah pottery was made—and it overlaps chronologically with it to some

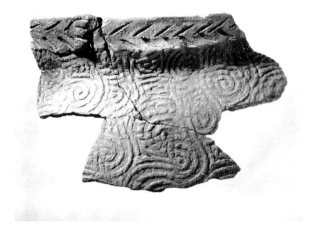

A Pisgah series jar fragment with a decorated collared rim and complicated curvilinear stamped exterior. Mica and other grit particles are visible in the paste. *Research Laboratories of Archaeology, University of North Carolina at Chapel Hill.*

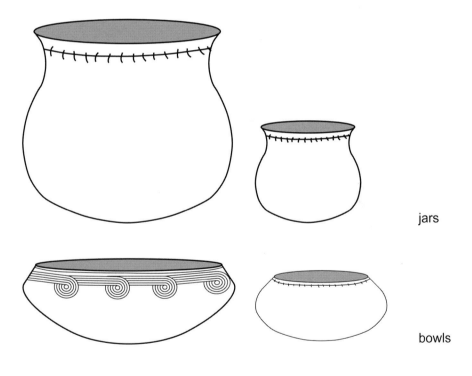

jars

bowls

10 cm

Basic vessel forms of Qualla pottery. *Research Laboratories of Archaeology, University of North Carolina at Chapel Hill; drawing by Chris Rodning.*

extent—this conclusion seems unjustified. The current understanding of Qualla pottery is that it emerged as another distinct Lamar variant with a mix of local and southern characteristics. In eastern Tennessee, Dallas series pottery was contemporaneous with Pisgah. Dallas complicated and incised pottery is related to the Lamar pottery complex, but the later historic period Overhill pottery made in eighteenth-century Cherokee towns in this region is not included in this complex. Overhill pottery is tempered with burned and crushed mussel shell rather than crushed rock or sand, and smoothed plain or burnished vessel exteriors are most common. Although both Qualla and Overhill pottery are quite distinctive, they do share vessel forms and some modeled decorative techniques like notched strips of clay added below the rim of vessels.[11]

QUALLA POTTERY: CHEROKEE TRADITIONS

A distinctive Cherokee pottery tradition in western North Carolina is recognizable at least as early as AD 1400 and perhaps earlier. Archaeologists call this stamped pottery tradition the Qualla series, and it was made with clay tempered with crushed rock and coarse micaceous sand. The interior surface of vessels tended to be burnished or polished. Qualla potters made two basic vessel forms: jars and bowls. Jars typically had constricted necks and flaring rims and seem to have been made in two sizes: larger ones with openings greater than twenty-five centimeters and smaller ones with openings around fifteen centimeters. Bowls were made in two forms: simple hemispheric ones and others with distinct shoulders and straight inverted rims called cazuela bowls. Using differences in vessel form, rim decoration, carved paddle stamp designs and temper, archaeologist Christopher B. Rodning has identified three chronological phases of Qualla pottery making over the centuries of its production.[12] I will briefly discuss and illustrate Early, Middle and Late Qualla pottery below.

Archaeological sites with the earliest manifestation of Qualla pottery have been identified in Out, Middle and Valley Town areas. This Early Qualla pottery (AD 1300–1500) exhibits similar diagnostic characteristics throughout western North Carolina. In examining two jar rim fragments recovered from a small Early Qualla phase community in the Valley Town region of present-day Clay County, North Carolina, Rodning has proposed features that are more commonly seen in Early Qualla pottery that may distinguish it from later Qualla pottery. The paste of this early pottery

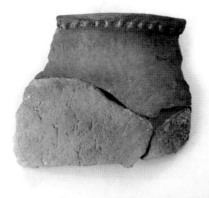

Left: Fragments of a small Early Qualla jar with a pinched rim strip below the lip. These fragments were recovered from a site close to the Spikebuck Mound in Clay County, North Carolina. *Western Carolina University Archaeology Laboratory.*

Below: Rim from a large Early Qualla jar. Note the "sawtooth" lower edge of the decorative rim strip applied below a rolled lip. Note also that the wooden paddle has left clear impressions of its wood grain between the carved curvilinear grooves. *Western Carolina University Archaeology Laboratory.*

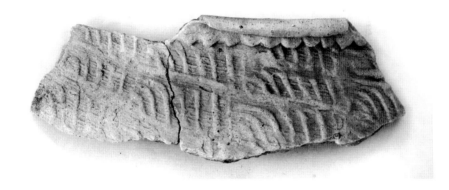

includes more sand as temper, and exterior surfaces of the pots are more often roughly smoothed than is common later. Jar rims with no decoration and those with added strips of clay with a scalloped or sawtooth lower edge also seem to be diagnostic of this phase. Finally, bowls with a simple profile and restricted orifice are more common than other bowl forms. Sometimes these bowls have a red mineral film covering their interior surface.

Middle Qualla (AD 1500–1700) pottery was less often tempered with sand, and stamping with paddles carved with complicated curvilinear geometric designs was very popular. Jars often had pinched rim strips added below the out-flaring lip. It was also common for jars to have wide shoulders with significant restriction above it. In distinction from earlier Qualla jars, jars from this phase rarely have plain rims. Cazuela bowls with decorative motifs incised across a prominent rim were also popular during this phase.

The characteristics that distinguish Late Qualla pottery (after AD 1700) include an increasing prominence of check stamping (the pattern produced

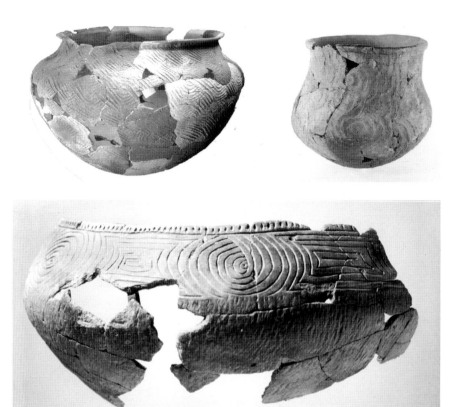

Top left: Reconstructed large Middle Qualla jar from the Birdtown Mound site in Swain County, North Carolina. Note the graceful form and proportions of this jar and the effect of the curvilinear complicated stamping on the exterior. *Research Laboratories of Archaeology, University of North Carolina at Chapel Hill.*

Top right: Small Late Qualla phase jar from the Townson site in Cherokee County, North Carolina. *Research Laboratories of Archaeology, University of North Carolina at Chapel Hill.*

Bottom: Partially reconstructed cazuela bowl from the Middle Qualla phase occupation at the Coweeta Creek site in Macon County, North Carolina. Note how skillfully the incised design was executed. *Research Laboratories of Archaeology, University of North Carolina at Chapel Hill.*

by a paddle carved with a crosshatched design) and other rectilinear patterns relative to curvilinear ones. The curvature of the neck of jars, that is the abruptness of the restriction above the shoulder, also tends to be less in later pots. Rim strips on jars and restricted bowls often stood out more from the exterior of the pot as compared to earlier rim strips and were filleted (segmented) or deeply notched.

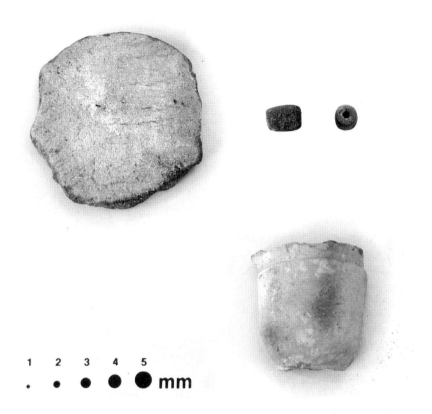

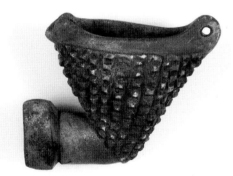

Above: Chipped disk made from an Early Qualla stamped vessel, modeled clay bead and a simple ceramic pipe bowl. All were recovered from near the Spikebuck Mound site in Clay County, North Carolina. *Western Carolina University Archaeology Laboratory.*

Left: Complex modeled ceramic pipe from the Middle Qualla phase Cullowhee Mound site in Jackson County, North Carolina. This pipe appears to be a miniature version of pots made to carry embers. *Research Laboratories of Archaeology, University of North Carolina at Chapel Hill.*

In addition to jars and bowls, other objects were made from ceramic pastes or even recycled potsherds. Broken pieces of pottery vessels, or potsherds, were often recycled by chipping or grinding the edges to form circular disks. These disks are thought to have been used in gaming, as one side would be smooth and burnished or polished and the other stamped with raised designs. Tempered clays were also used to make beads, disks and smoking pipes of various forms. Clay beads are common on Early Qualla sites, but their popularity declined when glass beads became accessible from European traders. Clay pipes are recovered from dwellings, but some forms were important ritual equipment and may not have been used outside council houses or other appropriate settings.

Qualla potters were very skilled and fashioned pots that functioned very well for cooking, serving and storing foods and liquids. But, as is obvious from the illustrations in this chapter, these potters also took pains to create vessels and pipes that are visually beautiful in their form and decoration. The specifics of form and decoration may have changed over time, but Qualla pottery remained distinctive from pottery made by their neighbors. Given that, it helped to establish a very long and proud tradition of the arts among the Cherokee tribe that is very much alive and well today. Cherokee potters today may carry on the Qualla pottery tradition or may find inspiration elsewhere. Regardless of the style they choose to produce, they have inherited a very rich heritage upon which to build.

Dr. Jane Eastman is director of Cherokee Studies and associate professor in the Department of Anthropology and Sociology at Western Carolina University.

ᎡᎶᎯ ᎢᎩᏁᎸ ᎠᎳᏍᏕᎳᏙᏗ

Elohi Iginelv Alasdeladodi
Earth *what.it.has.given.to.us as.an.aid*

LIVING OFF THE LAND

We have never recognized the art-crafts of the Indian as an asset to the nation's culture and a stimulus to our own industries. We echo Europe; whereas we might develop a decorative art truly American.[13]
—*Natalie Curtis, "Our Native Craftsmen," 1919.*

The Appalachian Mountains form an upland swath of rugged forested ridges and valleys that occupy about 1,500 miles of relatively unbroken wilderness. Running diagonally from northeast to southwest, the mountain range begins at the northernmost American border and fans out in a southwesterly direction into northern Alabama, where it is barely perceptible as a mountain range at all. At its heart are the Blue Ridge chain and Mount Mitchell, the highest point east of the Mississippi River. Many other points along the ridge make up the eastern Continental Divide, where waters on one side flow into the Gulf of Mexico and, on the other, into the Atlantic Ocean. This rugged landscape—America's mountain south—is the ancestral homeland of the Cherokee, a cultural and ethnic group that continues to inhabit a small portion of their original territory. Although there is little consensus as to when the Cherokee first inhabited this section of the American continent, most scholars agree that they have lived in this place for over ten thousand years.

Cherokee settlements were located in valleys formed by rapidly flowing rivers and creeks cutting through the mountains. Their towns varied in size from a dozen houses to much larger communities of several hundred

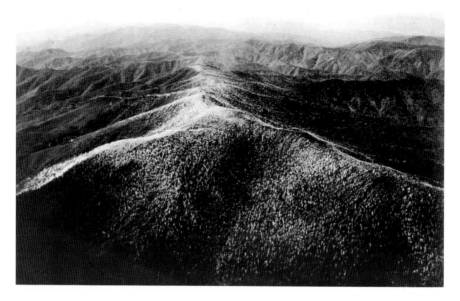

Great Smoky Mountains photographed by the Thompson Brothers. *Hunter Library Special Collections, Western Carolina University. Used with permission from Thompson Photo Products.*

people. Each town was made up of a ceremonial center, a cluster of homes, cultivated gardens and outlying fields. When Hernando de Soto arrived in 1540, he found them living in small villages, each separated by a few miles. During the forty years he spent as a trader among southeastern Indian tribes in the mid-1700s, James Adair counted sixty-four Cherokee towns and villages as part of "a numerous and potent nation,"[14] extending to portions of eight modern states.

CLAY AND POTTERY

Henry Timberlake, a colonial soldier who chronicled the region in the 1760s, described a forested landscape inhabited by "an incredible number of buffaloes, bears, deer, panthers, wolves, foxes, raccoons, and opossums" that provided the Cherokee with ample game. Timberlake described the environment as a "continual forest…[with] no scarcity of timber for every

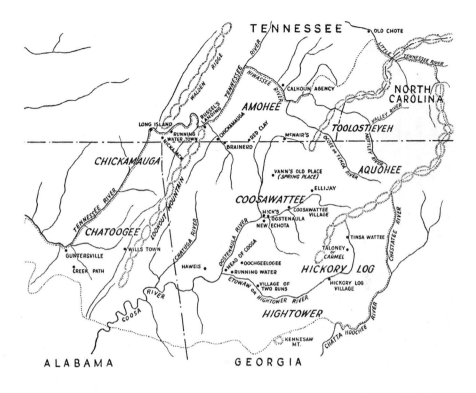

Cherokee settlement areas were grouped along the region's river valleys. *Bureau of American Ethnology Bulletin*, 1943.

use: there are oaks of several sorts, birch, ash, pines, and a number of other trees." The Cherokee put this timber to use in constructing their homes. Traveling through some of the same territory a decade later, William Bartram elaborated on their houses as consisting of logs "notched at their ends, fixed one upon another, and afterwards plastered well, both inside and out, with clay tempered with dry grass." These homes were located in individual settlement areas known as the Middle, Valley, Lower, Overhill and Out Towns. These independent communities were located in the mountains of western North Carolina, the valleys of South Carolina and along the river bottoms where east Tennessee meets north Georgia. Clustered around the Mother Town of Kituwah were the Middle Towns, including Nantahala and Cowee, an important economic center. Out Towns were located in upland forests to the east. Valley Towns and Lower Towns were located in the low lands to the west and south. The important Overhill Towns were situated "over the hill" on the western edge of the

Great Smoky Mountains. In his journey to Overhill Towns, Timberlake took note of the Cherokee's moccasins, bows, arrows, darts, pipes and cane baskets. Among the cultural objects he saw in use, he mentioned pottery. "They have two sorts of clay," he wrote, "red and white, with both which they make excellent vessels." He observed that some pottery "will stand the greatest heat." Timberlake also described how clay was applied to insulate their homes, which he poetically described as being "wattled with twigs like a basket." The wall surfaces were "covered with clay very smooth, and sometimes white-washed."[15]

Women held primary responsibility for the homestead, including the cultivation and harvesting of food crops. As an extension of their roles as preparers of foodstuffs, women were also the primary makers of their culinary tools, including baskets and pottery. Pottery is not considered as old as basketry, and its production indicates a certain settled existence among its makers. In an exhibition on native pottery, the Museum of the American Indian put it this way: "Those people who moved around a great deal could not make maximum use of fragile containers, nor take the time required to develop and perfect the ceramic arts." So finding

Reconstructed Cherokee homestead, circa 1750, Oconaluftee Indian Village. *Author's photograph.*

pottery to be abundant in Cherokee towns meant that the tribe maintained a certain settled existence. In his *History of the Indians* (1775), James Adair provided a bit more detail about Cherokee pottery than earlier accounts. His description reveals a variety of pottery forms in surprisingly large sizes, each suited to a particular purpose.

> *They make earthen pots of very different sizes, so as to contain from two to ten gallons; large pitchers to carry water; bowls, dishes, platters, basons, and a prodigious number of other vessels…impossible to name. Their method of glazing them is, they place them over a large fire of smoky pitch pine, which makes them smooth, black, and firm. Their lands abound with proper clay, for that use; and even with porcelain, as has been proved by experiment.*[16]

It was not only indigenous peoples who experimented with western North Carolina clay. In 1767, famed pottery manufacturer Josiah Wedgwood sent Thomas Griffith as his representative to obtain a supply for his pottery manufacturer in England. Griffith located a deposit of unusually white clay in Macon County, close to the Cherokee town of Cowee. Known to its Cherokee owners as "unaker" for its color, to Wedgwood this type of clay was kaolin. Eventually, five tons were shipped to England, where Wedgwood found it to be better than the local clays he used at home. Wedgwood used this very pure light-colored clay to make the white designs on Jasperware, his famous blue pottery. Although he tried several times to develop an effective export system to move clay in large quantities to England, the logistics proved impossible. Still, the reputation of the region as a source of natural raw materials persisted. By the early twentieth century, extraction industries—timber and mining—were in full swing. The fact that the area was touted as "a sublimely beautiful wilderness" did not slow the interest in industrial development. By 1912, "extensive lumbering and mining operations" were conducted near Dillsboro. "Talc and marble abound in the forest-covered slopes near the village, and quantities of high-grade kaolin [were] mined here and shipped to potteries throughout the country."[17] Such natural wealth attracted settlers and speculators to the Cherokee homeland. At one time, the Cherokee may have thought that the mountains themselves would be an effective barrier to encroachment. They had some measure of hope for this outcome when, in 1761, the British signed a treaty establishing the Blue Ridge as the edge of the colonial frontier. But even while the treaty remained in place, raids

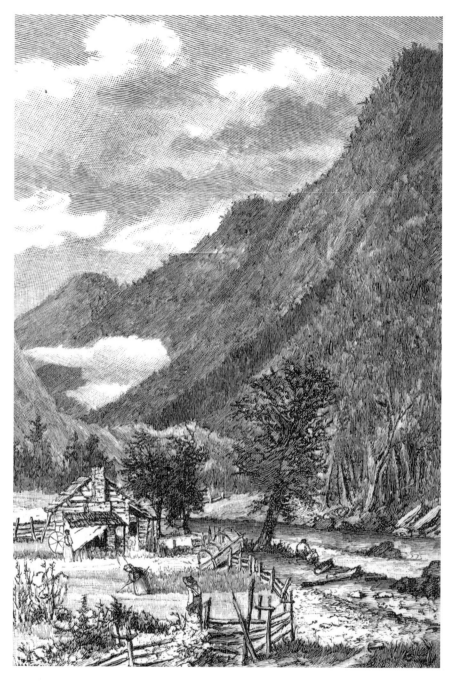

Cherokees and Euro Americans alike tended to settle in steep valleys along mountain streams, as pictured in *Heart of the Alleghanies*, 1883. *Hunter Library Special Collections, Western Carolina University.*

occurred along the ridgelines as intrepid settlers and industrial speculators, like Griffith, moved westward into the Cherokee heartland. The idea that the region was rich in natural resources—wild game, timber and minerals, including kaolin—was enough encouragement to continue making inroads into the heart of Cherokee territory.

A Century of Tears

For America's indigenous peoples, life in the 1700s could not have been easy, but it was, at least, sustainable. As the century progressed, the pressures of expansion and increased contact with outsiders took its toll, reducing native populations and uprooting native peoples. The one-hundred-year period from 1738 to 1838 was particularly difficult for Cherokee people, bringing devastation and hardship to their lives. A full century before removal, they experienced several waves of smallpox. Like other native populations in the Americas, the Cherokee had no natural immunity to nonnative diseases brought to the Western Hemisphere by incoming Europeans. Within a single lifetime, half the population—some say as many as 15,000 Cherokee men, women and children—died from disease. The latter half of the eighteenth century was not any better, marked as it was by a succession of treaties, land grabs, betrayals, battles and retaliation. The Cherokees suffered from a series of raids that left their communities devastated. One well-documented raid was made by General Griffith Rutherford in 1776. A hero by revolutionary standards, Rutherford sought to eliminate the Cherokees as a British ally, but in so doing, he cast brutal destruction on their communities. In the summer of 1776, Rutherford assembled a militia of 2,500 men armed with rifles, hatchets and small cannons. Entering into what is today Jackson County, North Carolina, he began his siege. His tactic was to enter a town, burn it to the ground, destroy all the crops and trees, kill or seize any livestock and kill anyone who resisted. If a town's inhabitants were not killed outright or did not escape, they were rounded up and sold as slaves. The prosperity of Cherokee towns succumbed to the brutality of his total destruction. Towns varying from fifty to one hundred houses were burned to the ground. Summer crops were trampled, and storehouses of food were burned as well, leaving the Cherokee homeless and without food.

The dawn of the nineteenth century brought talk of removing the Cherokee from their southeastern homeland. In 1830, this notion came to reality when President Andrew Jackson signed the Indian Removal Act. We

learn of the 1838 removal as the Trail of Tears, taught as if it were a single event, the displacement of a people within a year or two of history. In reality, the Cherokee people suffered devastation and destitution for more than a century. The epidemics, bloody encounters, burning of their towns and crops took their toll. By 1838, a seriously weakened and smaller Cherokee population faced their greatest trial. Families were uprooted, herded into concentration camps at gunpoint and forced to walk cross-country to Oklahoma. The memory of the Trail of Tears lives on in many family histories. Storyteller Freeman Owle recalled his great grandfather's story:

> *They told me that my family was, in 1838, in a log cabin near Murphy, North Carolina. All of a sudden someone was banging on the door early that morning. And they opened up the door and they looked out, and fifty Georgia soldiers were standing in the yard. They said, "Come out of the cabin." And when my great-grandfather…did, they burned the cabin to the ground.*[18]

Within the lifetime of a single generation—from removal to the end of the Civil War—day-to-day existence in the mountain south changed dramatically. For Native Americans, this time span was a period of displacement; for African Americans, it was a time of hope tempered by harsh reality; for European Americans, it was a time of political upheaval, untimely death and Reconstruction. It was not that the generations before had it easy, but with certainty, the Civil War swept through the south, creating a miserable existence for anyone in its path. After removal and the Civil War, the few Cherokee who remained in the eastern mountains adopted a constitution and formed a tribal government. In 1889, the Eastern Band of Cherokee Indians was formally incorporated and recognized by the State of North Carolina. By the dawn of the twentieth century, Cherokee life in North Carolina had changed significantly, reshaped by the surrounding Anglo culture. As John Finger points out in his history of the Eastern Band, "The new tribal society featured individual farms, nuclear families, and patrilineal descent; men eschewed warfare to become farmers, women learned the domestic arts."[19] Pottery and other domestic arts were practiced on a fifty-six-thousand-acre tract of land known as the Qualla Boundary, land owned by the tribe and held in trust.

While the Cherokee owned the lands within the Qualla Boundary, by the 1880s, railroads made it possible for outsiders to penetrate the interior of the Appalachian forest. Rail travel created access to the small towns and villages

Picture books such as *Western North Carolina R.R. Scenery* promoted the accessibility and beauty of the mountain south. *Hunter Library Special Collections, Western Carolina University.*

that made up the western North Carolina mountains, and outsiders began to take notice of the nation's unique eastern forests. As early as 1895, an article in the *New York Times* described the region as a lofty vacationland. "High up among the pine-clad mountain peaks of the Blue Ridge [is] the 'Land of the Sky,'" the article read. With rail as the primary mode of transportation, the writer claimed, "The railroad ride here from Asheville is one of the most picturesque and beautiful in the country. Everywhere along the route the scenery is wild and grand."[20]

ETHNOGRAPHIC INQUIRIES

While some travelers came into western North Carolina for recreation and others arrived as industrial speculators, ethnologists came to take a closer look at the Cherokee who remained here, the few not sequestered to Indian Territory in the west. At different times, Edward Palmer, Edward Valentine, James Mooney and M.R. Harrington each visited. In the summer of 1887, James Mooney came to study the eastern Cherokee as part of a fieldwork excursion for the U.S. Bureau of American Ethnology. Mooney purchased artifacts and visited a handful of Cherokee potters, but for the most part, his purpose was to collect stories that he later organized into his authoritative text, *Myths of the Cherokee.* In 1888, while Mooney was readying for a second trip to North Carolina, he was approached by William Henry Holmes, a fellow ethnologist who would become head of the bureau in 1902. At the time, Holmes was preparing "Aboriginal Pottery of the Eastern United States," an extensive study published as part of the bureau's *Twentieth Annual Report.* Apparently, Holmes did not anticipate visiting the Cherokee, and

TWENTIETH ANNUAL REPORT

OF THE

BUREAU OF AMERICAN ETHNOLOGY

TO THE

SECRETARY OF THE SMITHSONIAN INSTITUTION

1898–99

BY

J. W. POWELL
DIRECTOR

WASHINGTON
GOVERNMENT PRINTING OFFICE
1903

"Aboriginal Pottery of the Eastern United States" was published as part of the *Twentieth Annual Report of the Bureau of American Ethnology, 1903.*

instead, he "armed [Mooney] with a list of topics" and asked him to make "a careful study" of pottery among the eastern Cherokee. Mooney provided Holmes with information he gathered from visiting a handful of potters, and Holmes included Mooney's observations in two short sections of his larger report. His contributions focused on two specific topics: "Manufacture by Catawba Women" and "Manufacture by Cherokee Women." Mooney's sections are brief but important. While they cover a mere four pages in Holmes's two-hundred-page report, Mooney's is one of the only accounts of Cherokee pottery made in the post-removal period.[21]

Because of the "indestructible" nature of fired clay, pottery was available for study, even if pieces were no longer whole. In examining excavated pottery shards, Holmes believed that he could read "the stamp of each people…distinctly impressed upon its ceramic products." In his extensive paper, Holmes made a comparative analysis of pottery from various tribes, looking for traits to identify diverse styles and to locate "vanished peoples." A clear objective of Holmes's study was to identify the various methods of working clay as well as the variety of products made and used by different tribes. He hoped to extend his observations of specific cultural traditions to a broader cultural interpretation.

[The] *intimate knowledge of the art gained in the study of the technique of manufacture* [of pottery] *may also be of value when applied to questions of a more purely ethnic nature, for peculiar methods and devices of art characterize the peoples employing them, and in connection with other classes of evidence may be of use in tracing and identifying peoples.*[22]

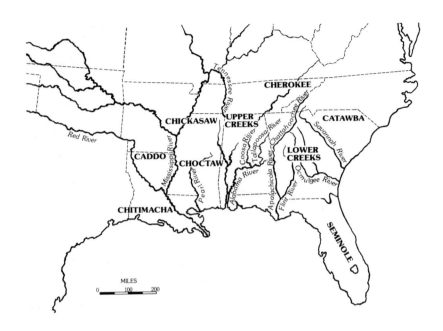

Map of the southeastern United States showing the locations of the major Native American tribes of the region. *Museum of the Red River, Idabel, Oklahoma.*

CATAWBA POTTERS AMONG THE CHEROKEE

The Catawbas lived to the southeast of the Cherokee in the Piedmont, along the border between North and South Carolina. As neighboring tribes, the Catawba and Cherokee experienced alternating periods of war and peace; as indigenous peoples, they shared some of the same devastating experiences. Epidemics, warfare and social disruption took a toll on both populations, and by the 1840s, the Catawbas had lost their land base as well. With a dwindling population, many moved west to live with their Cherokee neighbors. It was there, in 1888, that James Mooney met two Catawba potters, as he responded to Holmes's request to take a look at pottery making on the Qualla Boundary.

The first Catawba potter who Mooney wrote about was Sally Wahuhu (circa 1810–1888). It is important to remember that, although the Cherokee enjoyed a high rate of literacy among their population, they were literate in their own language. This meant that when names were written in English, they were recorded according to their sound. Since there is not a one-to-one correlation from the Cherokee syllabary to the English alphabet, the names

of many Cherokee people have alternate English spellings. Mooney met Sally Wahuhu during his trip to North Carolina in 1888; it appears that she died later that year. He reported that she was eighty years old and still making pottery. It is likely that she married a Cherokee man during the removal period and moved with him to Cherokee territory in North Carolina. During her forty years there, she made pottery in her native Catawba style. Wahuhu was sought out by ethnologists, including Edward Valentine, who bought her work in 1880. Because she lived in Cherokee, Valentine assumed that her pots were Cherokee made, adding to the confusion about the heritage of Cherokee pottery. Mooney did not make any pictures of Wahuhu nor did he record much information about her or her work.[23]

Mooney noted that Sally Wahuhu was getting too old to make pottery, but she was not the only Catawba potter living and working with the Cherokee during his visit. A much younger "skilled potter" was a relative newcomer, having moved to the Qualla Boundary just four years earlier. Susannah Harris was born on Catawba land along the banks of the Catawba River in what is now York, ten miles south of Rock Hill, South Carolina, near Charlotte. After the Civil War, she met Sampson Owl, a Cherokee man who was visiting her people. She and Sampson married in 1875, and in 1882, the couple moved to Cherokee. According to Catawba scholar Thomas J. Blumer, Susannah Harris Owl (1847–1934) was "an excellent potter and a willing teacher."[24] Owl seemed fully integrated into Cherokee life, having married a man who became principal chief in the 1920s. Susannah taught their two daughters, Camie and Ida, to make pottery. She may have also influenced Ella Arch, who was the mother of potter Cora Wahnetah, and after Camie Owl married into the Wahnetah family, the Catawba-Cherokee pottery bloodlines were blended further.

Sometime during the 1880s, Susannah Owl was joined by her niece, Nettie Harris. It is likely that Nettie came to live with her aunt Susannah so she could attend school in Cherokee. In 1889, Nettie Harris married Lloyd Owl, Sampson Owl's brother and, through the first decade of the twentieth century, lived with him in Cherokee. According to Blumer, when the accomplished Harris potters moved in, they provided the Cherokee "with the rare privilege of observing two of the finest potters of the Catawba tradition at work in their clay." He goes on to say:

> *Susannah and Nettie Owl arrived at Cherokee with an enthusiasm that would overcome the mountain remoteness of the area. The Catawbas remained confident and their tenacity brought success. As a matter of course,*

Left: Susannah Harris Owl holds a pottery vase made by her. *Blumer Collection, University of South Carolina–Lancaster.*

Below: This finely modeled pottery vessel with a snake motif was made by Susannah Harris Owl. *Blumer Collection, University of South Carolina–Lancaster.*

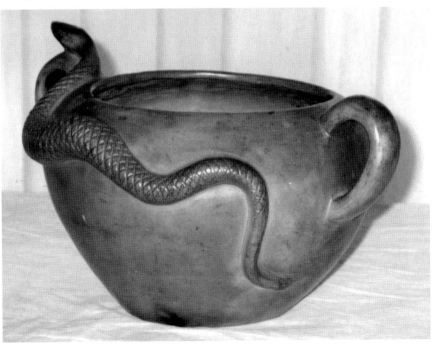

Nettie Harris Owl and a pottery vessel made by her. Potters Susannah and Nettie Owl were both part of the Harris family of Catawba potters. In the 1880s, both came to live on the Qualla Boundary where they made a living producing and selling pottery. *Blumer Collection, University of South Carolina–Lancaster.*

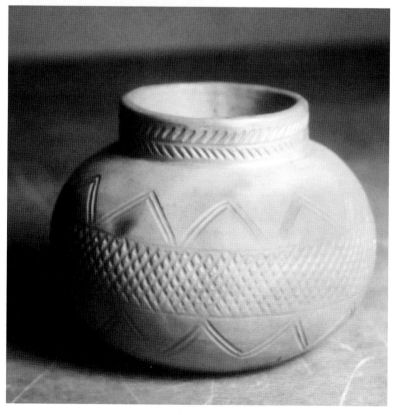

these two talented women sought a suitable pottery market, and once it was located, they made a living through their craft. In essence, they showed the Cherokees that a living was there to be made.[25]

The "living that was there to be made" was dependent on tourism, a phenomenon that increased dramatically in the first decades of the new century. Within a few years, it was possible to take a Pullman car from New York, Philadelphia, Washington or Cincinnati into Asheville to visit the "Land of the Sky." With an overland route into and out of the mountains, the development of industry expanded, while the area was simultaneously advertised as a vacationland. As more travelers came into Cherokee territory, potters responded to the growing market. Nettie Harris Owl (circa 1872–1923) and her aunt Susannah sometimes sold their pottery in bulk to shop owners who stocked their shelves for tourists. Nettie Owl's daughter, Lula Owl Gloyne, confirmed that the two made a good living. Buyers would "come down on the train and box the pottery all up and take it out," she said. Her great-aunt Susannah did not have to resort to peddling her pottery; instead, buyers came to her. Gloyne also talked about her mother, Nettie Owl, who carried her pottery to Waynesville and sold it there. "She made a good living," Gloyne remarked. As the tourist market for pottery expanded around the turn of the twentieth century, Nettie Owl began marking her pottery as "Cherokee." She was, after all, living in Cherokee with her Cherokee husband and selling through Cherokee outlets. Whatever her reasons, Nettie Owl began to label the base of her pots with phrases like, "Cherokee Reservation North Carolina 1904" and "Indian Reservation North Carolina 1904."[26]

During the first decades of the twentieth century, other members of the Harris family visited, and some moved for awhile to North Carolina. Pottery pipe maker Epp Harris moved from Catawba with his wife, Martha Jane Harris, and daughter, Margaret. They rented a house from the Owl family and lived in Cherokee for at least two years, during 1913 and 1914. The year 1914 was a watershed for Cherokee cultural celebrations. This was the first year of the annual Cherokee Indian Fair, a festival celebrating both agriculture and handcraft, giving pottery a new outlet. The fair provided tourists a new venue for visitation. Within a decade, Sampson Owl opened his own store, one of the first tourist shops in Cherokee. While he did not carry Cherokee-made goods exclusively, Owl did provide a dependable outlet for locally made pottery and baskets. To meet the demand (or maybe just to be supportive of family), Owl also traveled to Rock Hill to buy pots from his

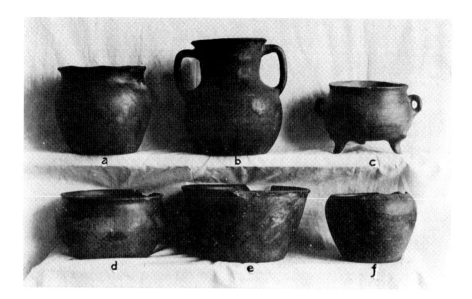

Catawba pottery. *Photograph by M.R. Harrington, 1908.*

wife's extended family, purchasing pieces from Margaret Harris, who had moved back to live among her people. By the mid-1920s, some roads into and out of Cherokee were paved, giving tourists an alternate means to travel into the area. The market for pottery—especially pots marked "Cherokee," whether they were Cherokee-made or not—were in high demand. Around this time, Nettie Owl had died, and Susannah was "passed her years of great production."[27] The remaining potters had a ready market and a difficult time keeping up with demand.

DᏝᏗᎫ ᎢᏴᎶᎫ

Adanedi Iyvdvdi
gift to.do

A SHARED TRADITION

So she went down to the river and got some mud, just like the mud dauber made, and she made a little bowl. And she put it out in the sun/and let it get real hard, and then she tried to put water in it, after she had put it in the fire and made it real hard. And sure enough/she could carry more water that way, and without it leaking like the basket did.[28]
—*Kathi Smith Littlejohn, "Me-Li and the Mud Dauber."*

MODES OF LEARNING

Like all studio craft processes, pottery making can be learned in a variety of ways. The oldest and most traditional way of learning a skill is through family and family connections. In many parts of the world and throughout history, family tradition usually dictated a person's livelihood. Hand skill and an understanding of materials was often a closely guarded secret, with proprietary knowledge passed from mother to daughter or father to son. Traditional learning sometimes takes place as direct instruction; among the Cherokee, it is more often taught through observation. If one learns a craft through family or cultural tradition, knowledge tends to be holistic, encompassing more than the particulars of a skill or technique. Traditional learning may include an approach to work as a discipline, values inherent in the practice or a related spiritual dimension. Families in traditional cultures often repeat forms, patterns and motifs that signify their lineage. Even after many years, a vessel or basket is recognizable as unique to a family line.

Traditional knowledge is passed from generation to generation through observation. While he did not grow up to weave baskets, John Henry Maney helped his grandmother, famed basket weaver Nancy Bradley. No doubt Maney was able to learn a respect for materials and their properties, knowledge that would later inform his work as a potter. *North Carolina State Archives, Travel and Tourism Division Photographic Files; photograph by Bill Baker.*

Tradition, as a mode of learning, is stable as long as the culture itself is stable, but traditional learning can be interrupted by disruption within the social structure. Such disruptions, in turn, affect the even flow of tradition and the passing of knowledge to the next and subsequent generations. The Cherokee, like all native peoples, were makers of pottery long before their contact with Europeans. The unsettling century that overlapped with the

A Shared Tradition

1838 removal wreaked havoc on their ability to practice domestic traditions. Still, for many, material objects were keepers of tradition in the same way that stories and song remind us of who we are. Sometimes these stories are joyful; at other times, they are human-scale memorials marking tragic events. Edna Chekelee treasures a centuries-old container and imagines the stories it holds.

> *There was a basket that was give to me in Oklahoma. I don't like to talk about the Trail of Tears, but it's really sad. And sometimes it gets to me, and sometimes I can feel it. Especially when I got a basket that I carry that's over a hundred and fifty years old, and it's still good and sturdy, and it's a white oak basket that went on the Trail of Tears. No telling how many people have died in front of this basket. If this basket could talk to you, there's no telling what it would tell.*

I. Mickel Yantz, curator of the Cherokee Heritage Center, tells the same story through the absence of objects.

> *Cherokees were ripped from their homes and only allowed to take a small portion of their belongings. The walk from southeastern homelands to Indian Territory proved treacherous. As the days grew colder and the walk more difficult, they burned their few belongings for warmth or left them behind to lessen the burden. This difficult exodus saw few objects come to Indian Territory, and left no evidence of pottery.*

Containers that traveled along the Trail of Tears functioned metaphorically as vessels of hope, holding and protecting items dear to one's heart and crucial to a family's survival. Containers held value. Water, food and medicinal plants were not readily at hand, and a group's very survival may have depended on the ability of a container to store provisions for a later time of want. The ability to hold, save and protect satisfied early human needs, separating the precious from the ordinary, the valued from the valueless. For those who are willing to "read" material stories, there is much to be learned from handmade objects.[29]

This interruption in Cherokee life refocused priorities onto survival, causing the Cherokee to depend on other methods of maintaining craft skills during this tumultuous period. One other way that hand skill transferred is through diffusion, the way that Catawba and Cherokee potters shared their work at the turn of the twentieth century. A cross-cultural transmission

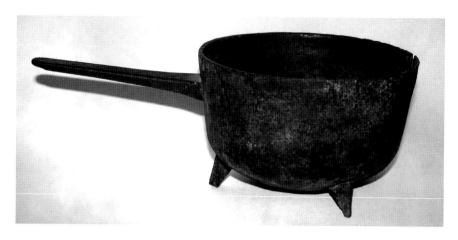

This cast-iron pot traveled along the Trail of Tears with a Cherokee family to Indian Territory, known today as Oklahoma. *Cherokee Heritage Center, Tahlequah, Oklahoma.*

of traditional knowledge often follows patterns of migration and has the effect of blending traditions. When Africans were brought to the American continent, they brought with them their skill of making stringed instruments. Much later, when waves of immigrants came to build an American industrial workforce, a diverse set of Old World craft skills traveled with them. The result of this type of cross-fertilization is often the adoption of techniques and new forms applied to a traditional repertoire of craft production. When cultural traditions are shared among different peoples, there can sometimes be unexpected results. For decades, many Cherokees thought that the Catawba-style pottery that they knew so well was authentically Cherokee. In cases where culture transmutes, craft objects are modified, resulting in blended forms that become authentic in the context of cultural change.

It is not only forms themselves that are affected by diffusion, but ideas about crafts as well. The Cherokee may have assimilated specific pottery forms from the Catawba potters among them, but they also absorbed some of the values held by those potters. It may very well be that the primary difference between Catawba and Cherokee pottery was not so much a matter of style, as it was a matter of intention. Cherokee pottery was made for domestic purposes, for cooking and serving in a foodways tradition. Catawba pottery evolved into a tourist product, departing from tradition; it was designed and made to be sold. A willingness to adapt to market forces changed pottery production in those first decades of the twentieth century, as potters formed alliances and developed markets for

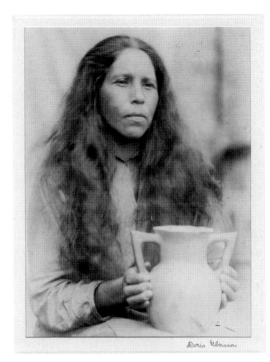

Left: An unidentified Catawba potter photographed by Doris Ulmann in 1929 holds a double-handled clay vessel. Ulmann's portraits often included an attribute held by the sitter to indicate the person's trade or profession. *Ulmann portrait courtesy of Doris Ulmann Foundation and Berea College.*

Below: The postcard labeled "Making Cherokee Pottery" includes potter Lillie Bryson on the porch of her home. Although Bryson was Cherokee, the pottery vase (lower left) is clearly made in the Catawba style. *W.M. Cline postcard in the collection of the Southern Highland Craft Guild Archive.*

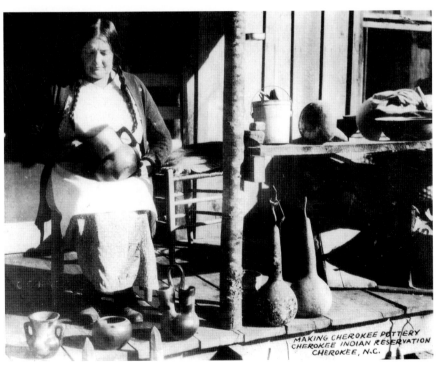

MAKING CHEROKEE POTTERY
CHEROKEE INDIAN RESERVATION
CHEROKEE, N.C.

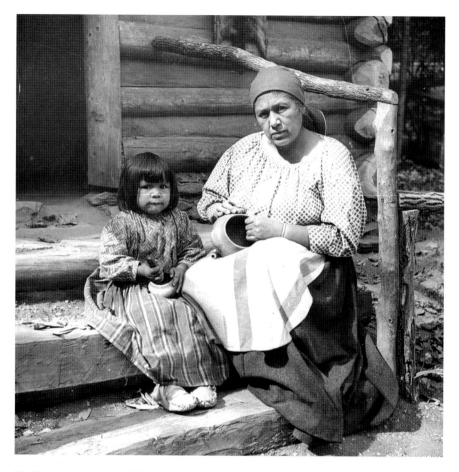

Traditional pottery knowledge was often passed from mother to daughter. Cora Wahnetah with daughter Margaret. *Qualla Arts and Crafts Mutual, Inc.*

both traditional and innovative forms. The Cherokees assimilated various tribal forms in other ways. Most notable was their exposure to a collection of archaeological specimens owned by Asheville bank executive and amateur mineralogist Burnham S. Colburn. Living in an idyllic section of Biltmore Forest, Colburn amassed a large collection of Native American artifacts that were made available to Cherokee artisans and organizations. Colburn gave photographs of artifacts in his collection to Harold Foght, superintendent of the Cherokee Indian Agency. Crafts teacher Gertrude Flanagan recalled that several craft teachers visited the collection. Maude Welch remembered getting new ideas for pottery forms from seeing his archaeological finds.[30]

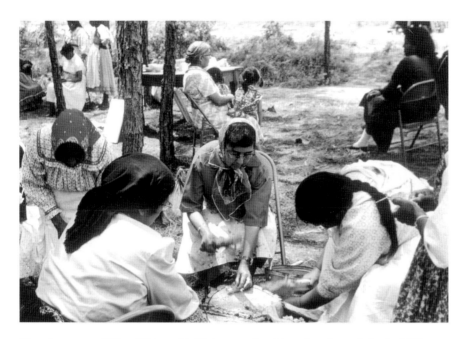

Over the course of Cora Wahnetah's lifetime, modes of learning changed. In the 1930s and 1940s, a craft skill was a generational legacy. By the 1960s and 1970s, even traditional knowledge was sometimes shared at workshops, like this one taught in 1965 in Choctaw, Mississippi. *National Archives and Records Administration.*

Three other modes of learning are briefly mentioned here. These are apprenticeship, self-teaching and professional study. In Europe and in colonial America, the most common way that someone learned a craft was through a formal apprenticeship. An apprentice usually lived with a master craftsman and worked for a prescribed number of years before traveling to expand acquired skills as a journeyman. Throughout history, craftsmen learned effectively through this method. Being self-taught or learning through professional means has also produced very fine craftsmen. Amanda Swimmer learned pottery as an informal apprentice at the Oconaluftee Indian Village. Lucy George was a self-taught basket weaver. Amanda Crowe, one of Cherokee's best-known sculptors, attended the Art Institute of Chicago where she honed her skills following a professional course of study. Of course, many craftsmen—Cherokee potters included—learned their craft through a variety of methods. Rebecca Youngbird is a good example of someone whose skills advanced through multiple channels of learning. As Youngbird's life and work will demonstrate, the mechanics of making pottery among the Cherokee depended upon all five of these methods.

PRODUCT AND PROCESS

This short dialogue on craft practice is meant to provide context for the more targeted discussion of Cherokee pottery that follows. In looking more closely at Cherokee pottery, it is important to make a distinction between craft product—the pottery itself—and the process or skills used to produce it. Museums are in the business of preserving aesthetic objects and archaeological and historic specimens for study and appreciation. The skills that went into making an object—the process of its making—can only be preserved by those who continue the activity of a hands-on tradition. This emphasis on process was explored in several chapters in the 2003 text *Objects & Meaning*, where I explain this distinction,

> [My] *concern is not the value of a work, but the value of its working. In considering the effect that creative process may have on its maker, its holder and, collectively, on the culture in which it exists…the value inherent in an object is also the value inherent in its making.*[31]

Today's object is critically positioned as a fulcrum between maker and viewer and between making and perceiving. Indeed, process may be the key sustainable aspect of our aesthetic future. Divisions that separate and classify completed objects focus our consideration on differences in form—what is "fine" art and what is not—and ignore the common bond of making found in studio process. Such categorical distinctions contribute to the intellectual and economic devaluation of handwork and the handmade object. In contrast to an object existing apart from its social milieu for purely aesthetic purposes is the notion of the socially integrated object. One of the strongest proponents of such an imbedded value was Allen Eaton, a curator and author of several mid-twentieth-century books on handcraft. Eaton focused on the intangible values of the object and its function—the effect of the work on producer and consumer—rather than on the object as a product in its own right. "Every kind of work will be judged by two measurements," Eaton wrote again and again, "one by the product itself…the other by the effect of the work on the producer." Eaton hoped to imbue hand process with value in and of itself in an attempt to return dignity to labor. His view of craft remained diametrically opposed to the idea that the object has a singular aesthetic purpose. Eaton made a visit to the Qualla Boundary in the fall of 1931 for the purpose of inviting the Cherokee to join the Southern Mountain Handicraft Guild.[32] Presumably he returned because he was able to include their work in the 1933 exhibition *Mountain Handicrafts* and in his 1937 book, *Handicrafts of the Southern Highlands*.

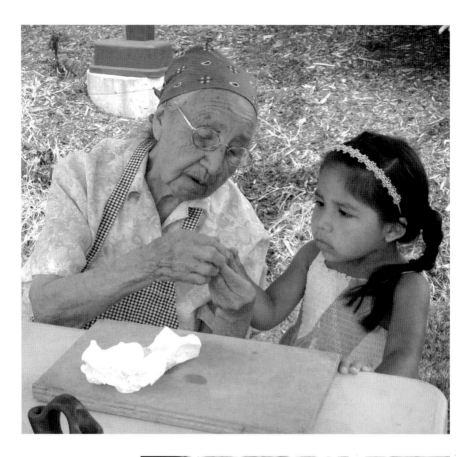

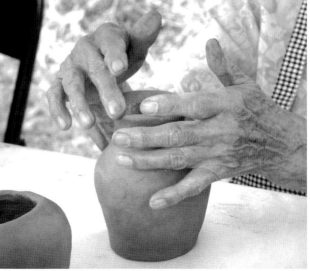

Cherokee children learn about tribal traditions by observation and close family relationships. Amanda Swimmer and her great-granddaughter, Tah-tah-yeh, at Cherokee Voices festival, 2010. *Author's photographs.*

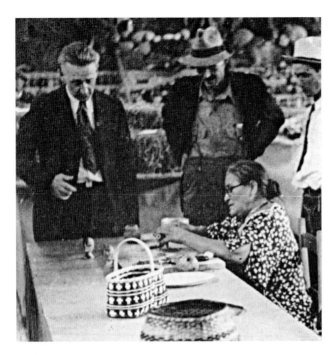

A champion of mountain crafts, Allen Eaton (left) watched as Maude Welch demonstrated pottery making at the 1940 Cherokee Indian Fair. *Museum of the Cherokee Indian.*

LILLIE BRYSON

By the late 1920s and early 1930s, new markets and a growing interest in cultural traditions brought other potters to the Qualla Boundary. Lillie Beck Bryson (1876–1951) was a Cherokee woman who was raised off the Qualla Boundary in Rabun Gap, Georgia. Her life and work is somewhat difficult to track because she married several times and each time took the name of her current husband. She was alternately known as Lillie Beck, Sanders, Saunooke and Bryson. I will refer to her as Lillie Bryson, the name she was best known by as a potter. In 1910, Lillie Beck married her first husband, Joseph Sanders, a Catawba, and moved with him to South Carolina. While there, she learned to make pottery from Sarah Harris, an accomplished potter and her husband's grandmother. As Lillie Sanders, she made pottery in South Carolina for twenty years following the style of the extended Harris pottery family. When her husband died in 1930, she moved to western North Carolina and married Joseph A. Saunooke, who was elected as principal chief in the 1910s and 1920s. While living in Cherokee, she continued to make pottery for another twenty years and, after 1931, began to label her pottery "Cherokee," although her work clearly remained in the Catawba style.[33]

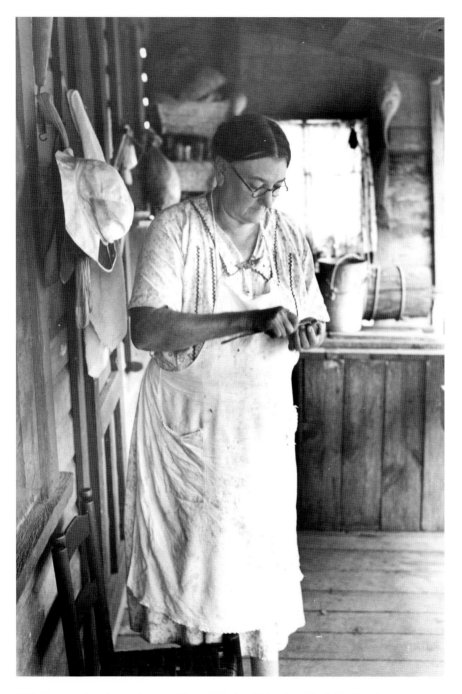

Lillie Bryson trimming a clay pot. *Blumer Collection, University of South Carolina–Lancaster.*

In 1932, Joseph Saunooke died, but Lillie remained on the Qualla Boundary. By the time Czechoslovakian-born anthropologist Vladimir Fewkes did his fieldwork there in the late 1930s, she had married a Bryson and was living in Ela, a small community between Cherokee and Bryson City. Fewkes noted that Bryson made "Catawba-style" pottery. Even though Lillie Bryson herself was Cherokee, the effect of her work on the Cherokee pottery tradition was to further strengthen, rather than weaken, the Cherokee's connection to the Catawba style. Through her family ties to the pottery-making Harris family in South Carolina, Beck provided access to Catawba clay deposits. This arrangement worked well for a time, but the relationship began to dissolve in the late 1930s. When Susannah Owl's grandson, Samuel Wahnetah, arrived to secure a large amount of clay from the Catawba's well-used clay holes, he was rebuffed. The Cherokee depended on their own clay deposits, but these became unavailable after a time. Some were simply used up and others were paved over. Amanda Swimmer recalled a place where she dug clay. Her property abuts the Great Smoky Mountains National Park, and when the park built a road, "they covered my clay up," she remembered. "That's where we used to get our clay, and now you can't get it. They piled all that dirt in there." When clay deposits were exhausted or disturbed, Cherokee potters turned to commercial clays.[34]

When the clay holes proved too difficult to work, potters turned to commercial clays. *North Carolina Folklife Institute and North Carolina Arts Council; photograph by Cedric N. Chatterley.*

Rebecca Youngbird

A second Cherokee woman who was influenced by the Harris-Owl potters was Rebecca Youngbird. Rebecca "Amanda" Wolf Youngbird (1890–1984) was the daughter of a non-Indian woman and a Cherokee named Comeback Wolf, a man who acquired his name from the circumstances of his birth. According to Youngbird's own story, her family was on its way west along the Trail of Tears, when they turned back at the Mississippi River. The details of how they escaped and returned to North Carolina are unclear, but her father was born on the return trip home, thus earning him the colorful name of Comeback. The potter's given name was Rebecca, in homage to her grandmother who had made that trip, but close friends called her Amanda. Youngbird was born in 1890 and lived on the Qualla Boundary until she was thirteen, when she was sent away to boarding school in Carlisle, Pennsylvania. Back home in Cherokee, while still in her twenties, Youngbird began experimenting with clay. "I first started with clay I found

right here…There was a streak of clay down by the branch on our property, and I got some clay there and practiced. Nobody taught me. I just did it myself." In describing designs she added to her pottery, Youngbird explained

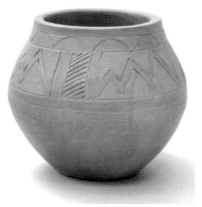

Above, left: Cherokee potter Rebecca Amanda Youngbird. *National Archives and Records Administration.*

Above, right: Incised pottery vase by Rebecca Youngbird. *Qualla Arts and Crafts Mutual, Inc.*

how she tried new ideas. "I found some of those designs in a little book that somebody made who knew about those things." She bought "a little wooden paddle and had somebody carve it for me" and then finished her pottery by paddling and incising. Youngbird also talked about experimenting with other tools. "I had lots of little tools. A friend of mine knew I wanted crooked knives and he made me three and it was sharp and wide and on a wooden handle, eight inches long. [It was] used to scrape inside." Youngbird knew Nettie Owl, and after Lillie Bryson moved to Cherokee in 1930, Youngbird also became acquainted with her. Youngbird and Bryson gathered clay together and compared their work, sharing information and insights. Blumer reminds us that, because of her upbringing outside of the usual familial tradition, she had to forge her own way. "Rebecca Youngbird had to resort to her own ingenuity since she did not rely on an ancient family tradition."[35]

WEDDING VASE AND BLACKWARE

Aside from the relationships Youngbird had with potters who lived close to her, some of her inspiration may have come from unexpected sources. In 1934, Youngbird was invited to Atlanta to demonstrate at the Southeastern Fair. This annual fair began in 1915, a year after the tribe began holding its own Cherokee Indian Fair every fall. Both fairs were typical harvest festivals, with agricultural competitions, industrial exhibits and a midway of rides. Craftwork was usually a component, with craftsmen demonstrating and sharing their skills and sometimes competing for awards. In 1934, the Southeastern Fair added an "attraction of unusual interest." The cultures of twelve different tribes, including Seminole, Pueblo, Navajo and Cherokee, were on display as part of four Indian villages constructed on site. A subsequent issue of the *Atlanta Constitution* emphasized craft demonstrations, using handwork to convey a broader cultural awareness. The article promised an "opportunity" for visitors. "By their handicraft you shall know them," the writer noted rather prophetically.[36] At the Southeastern Fair, Atlanta reached out beyond its southern roots to bring in potters from as far away as San Ildefonso, a Pueblo village near Santa Fe, New Mexico. Maria Martinez, a craft maker of national reputation, represented their pottery traditions. Martinez was credited with revitalizing Pueblo pottery after a 1908 excavation revealed samples of a satiny black-on-black pottery that was no longer made. By the 1920s, Maria and her husband, Julian, were reproducing ware in this

style, establishing a reputation through their association with museums, archaeologists and collectors.

At the Southeastern Fair in Atlanta, Rebecca Youngbird found herself in the company of Pueblo potters and watched as Maria Martinez constructed her pottery. There is some uncertainty as to whether this fair led to the introduction of the double-spouted wedding vase into the Cherokee pottery repertoire, as Youngbird also said that she saw this form in a book. The double-spouted form has obvious significance with its merging of two forms into one. Amanda Swimmer explained its use: after the bride and groom drink out of one side or the other, they throw the vase over their shoulder. "If [the vase] didn't break, the marriage would stand," she said. It is doubtful that many put the vase to the test. Such a wedding vase, or wedding pitcher as it is sometimes called, was collected by University of Pennsylvania professor and scholar Frank Speck. Speck interviewed the vase's maker, Lillie Bryson, who told him that it was she who conceived of this form. Bryson would not be the first artist to stretch the creative truth, but wherever its origin, the wedding vase quickly became a staple form repeated by Bryson, Youngbird, Maude Welch and subsequent generations of Cherokee potters. By the late 1930s, Catawba potters traveling to Cherokee to sell their pottery noticed the new form, and the double-spouted vase quickly became a common Catawba form as well. Blumer noted their willingness to see a particular form as marketable and "make the form look quite at home."[37]

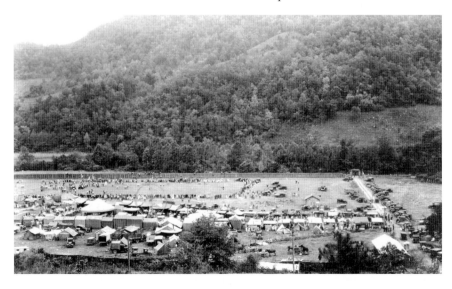

The Cherokee Indian Fair, begun in 1914, brought visibility to Cherokee crafts. *University of North Carolina Library at Chapel Hill.*

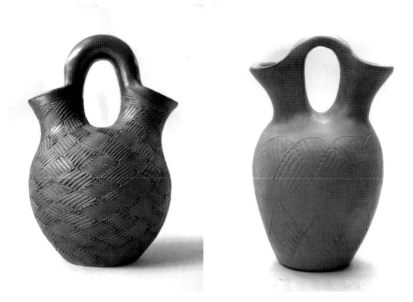

Above, left: Wedding vase by Rebecca Youngbird. *Qualla Arts and Crafts Mutual, Inc.*

Above, right: Wedding vase by Amanda Swimmer. *Qualla Arts and Crafts Mutual, Inc.*

When James Mooney located Sally Wahuhu and Susannah Owl making pottery on the Qualla Boundary, he asked them to demonstrate their methods. For the most part, he concluded that their methods were "probably in the main Catawban," but he learned from Sally Wahuhu that their method of firing to produce "a rich black color" was acquired from the Cherokees. Little is known of whether this method of producing blackware continued into the first decades of the twentieth century and some have postulated that Youngbird may have reintroduced black-on-black ware as well, perhaps, inspired by her observation of Pueblo potters. Whether Youngbird was the sole maker of blackware in the 1930s, by the 1950s, it was certainly a signature style. A magazine noted that her blackware pottery was "instantly recognized." Youngbird's enthusiasm was evident. "I sold them in the shops and they'd say, 'Oh this is beautiful. This is prettier than the last bunch.' I got so I was making a real good living at it."

Always resourceful, Youngbird explained how she achieved these results by firing pottery in her kitchen cook stove. "I'd put some old corn with grain still on it and some with only cobs and that's what

made 'em black. I never put them in a bonfire. I used wood, hickory, 'til the pottery got hot, then I'd add the cobs and they'd stay black."[38] Certainly, the popularization of the wedding vase and blackware finish are innovative adaptations that became "traditional" Cherokee forms in their widespread production and use.

Maude Welch

Maude French Welch (1894–1953) was a third Cherokee potter with strong ties to the Catawbas. She was born at the end of the nineteenth century near Cooper's Creek in the Birdtown section of the Qualla Boundary. She was related to the Owl family and, perhaps, knew of their pottery. Her mother was not a potter, but she did make baskets. Welch left Cherokee in 1925 to seek factory work and went with her children to Rock Hill, where they lived for a time with the Blue family. Her daughter, potter Edith Welch Bradley, remembered moving around to find factory work. Besides living in South Carolina, her family also lived in Florida, where her parents worked as spinners in various cotton mills. Catawba potter Doris Wheelock Blue recalled the Welches' stay in Rock Hill: "While they were here we were making pottery, and they watched us. They were real interested." They moved in next with Georgia Harris, another of Catawba's established potters. "They watched her make pottery with her grandmother, and they learned how to make pottery." She concluded, "When they went back to Cherokee, they became experts." During the time that Maude Welch lived among the Catawba, she was able to observe four of that tribe's best potters: Rosie Harris Wheelock; her daughter, Doris Blue; Martha Jane Harris; and her granddaughter, Georgia Harris. Having interviewed many Catawba potters, Thomas Blumer noted that the "Catawbas are adamant in their insistence that Maude Welch never worked in clay while visiting in their homes. She merely observed." Still, such observation is consistent with traditional and familial ways of teaching and learning, and no doubt, Welch was able to absorb what she learned during her stay in South Carolina. After Welch returned to the Qualla Boundary, she began producing pottery in earnest. Her daughter, Edith Welch Bradley, recalled, "After we moved back to Cherokee, Mama said, 'Well, I believe I'll try to make some pottery.' She made a few canoes and bowls. She sold them and got some more clay." It appears from her comments that Welch's initial attempts at pottery making met with immediate success, a success that continued for years to come.

Her daughter continued, "Every year mama won first prize for her pottery." Maude Welch remarked that she quickly learned that pottery sales could help with groceries; she could trade pots for "a sack of flour, some lard, and a box of salt."[39]

In North Carolina, Welch obtained clay for her first pieces of pottery from a neighbor. For a time, she traveled to South Carolina, a trip made as much for visiting friends as for digging clay. Afterward, she used the community clay hole at the Macedonia Church in Soco. "I used to dig it out of holes along Cooper's Creek and in Soco Valley," she said. When those deposits were exhausted, she purchased clay from Brown Pottery in Arden. Welch continued to add to her reportoire of traditional pottery forms by looking at photographs and museum pieces, making peace pipes, medicine bowls and wedding pitchers. Sometimes she added decorative lugs or Indian heads to her pots. These she made entirely by hand as well, although some may think that they were molded. Instead, she hand formed these motifs and pressed them onto her pot while it was still wet. At one point, she did try using molds to make the heads, but the ones she formed by hand were so much better that she abandoned the molds and continued to fashion the heads by hand. Welch used a variety of tools to shape her pottery and sometimes used a moist rag to smooth its surface. Fewkes observed, "Her tools depend more on modern kitchen pieces than on native means." Welch used small knives to shape her pottery and, like so many potters, used the same polishing stone for over twenty-five years. Using this cherished possession, Welch explained how she finished her pots. "I polish them up smoother and add more designs so that people will buy them." A 1935 report on pottery called her "the most talented potter on the Reservation." The writer concluded, "Maude Welch, makes a unique type of pottery with many personal elements which was neither like old Cherokee pots nor Catawba."[40]

Welch was aware of potters' wheels and pottery kilns. In the mid 1930s, she taught for a time at the Cherokee Boarding School. Apparently, in its move to reintroduce Cherokee crafts into the school system, the federal Cherokee Indian Agency decided to modernize the process by introducing the use of kerosene-fired kilns. For the most part, Cherokee potters fired their pots in wood or coal stoves that did not provide enough heat to fully mature the clay. In spite of the pressures that may have come with teaching and adaptations to more modern methods, Welch continued with the "old way." She dried her pots in the sun before putting them into the oven of her kitchen stove. Once throroughly heated, she placed them into the firebox to complete the firing. Placing a pot into the firebox exposed it to the flame,

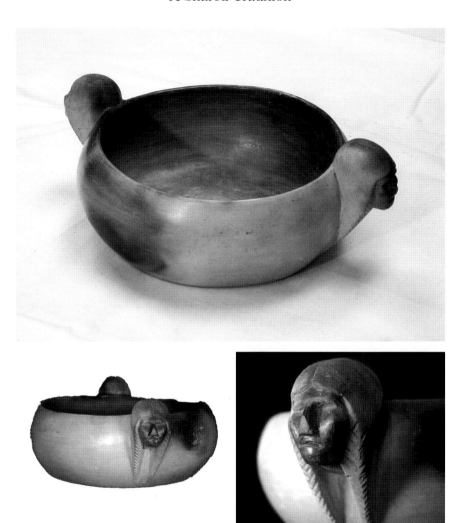

Pottery bowl with Indian head handles by Maude Welch was made in the Catawba style.
Mountain Heritage Center, Western Carolina University.

which added a finishing touch of color. This method produced work with a varied organic surface, ranging from light orange to dark brown in a natural color palette. Her "mottled tan and smoky-black pottery is recognized on sight," one writer noted.[41]

Like Rebecca Youngbird, Maude Welch was exposed to other potters through her attendance at outside fairs and festivals. She is pictured locally at the 1940 Cherokee Indian Fair, where she demonstrated her craft. She

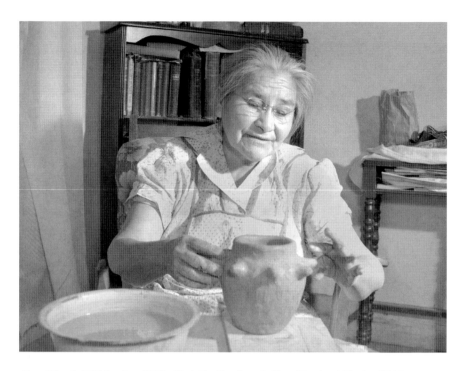

Above: Maude Welch, circa 1950. *North Carolina State Archives, Travel and Tourism Division Photographic Files; photograph by Bill Sharpe.*

Below: Maude Welch working on the porch of her home. *Qualla Arts and Crafts Mutual, Inc.*

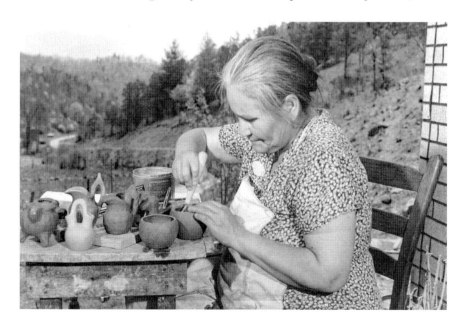

is also known to have demonstrated at the second Craftsman's Fair of the Southern Highlands, held in Gatlinburg in 1949 and, most likely, attended in other years as well. In spite of her exposure to new ideas, Maude Welch explained her intention to hold fast to the "old way":

> *I attended the Southern Guild Fair* [Craftsman's Fair of the Southern Highlands] *and I learned how other pottery makers used kilns for the burning of their pieces. I decided I would try to make mine that way, but the people didn't want it. They said mine were different—the only pieces of the kind anywhere—so, I decided to hang on to the old way, not to modernize.*

Welch was totally emersed in making pottery, noting that she felt "lost when she was not carving or polishing a piece." Her work did not go unnoticed. Some have gone so far as to say that "the influence of Maude Welch, it seems, might have caused a complete revival of the potters' art among the Cherokees."[42]

ᏣᎳᎩ ᏍᏗᏓᏍ �

Tsalagi Gadaguga Datsilosdv'i
Cherokee pottery where.it.is.pictured

GALLERY OF CHEROKEE POTTERY

The daily act of making is a ritualized process and the resultant object allows its holder to participate in ritual through use. The repetitious activity of making and a self-conscious awareness of the object through use characterize ritual in craft process....From the potter's hand to the user's hand, the object flows from a rhythm of making to a daily ritual of holding.[43]
—*Anna Fariello,* Objects & Meaning

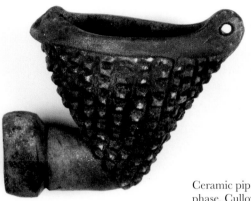

Ceramic pipe (2" x 3"), Middle Qualla phase. Cullowhee Mound, Jackson County, North Carolina. *Research Laboratories of Archaeology, University of North Carolina at Chapel Hill.*

Mother and Child terracotta sculpture (5" x 5" x 3"). Amanda Crowe. *Southern Highland Craft Guild Archive.*

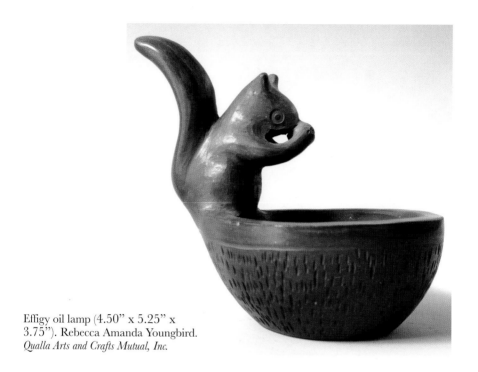

Effigy oil lamp (4.50" x 5.25" x
3.75"). Rebecca Amanda Youngbird.
Qualla Arts and Crafts Mutual, Inc.

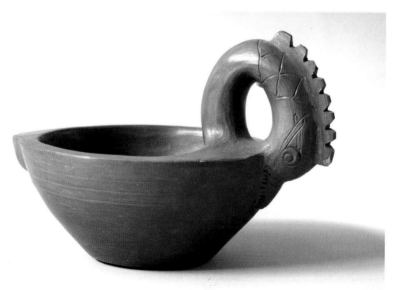

Effigy oil lamp (4.50" x 7.00" x 4.75"). Rebecca Amanda Youngbird. *Qualla Arts and Crafts
Mutual, Inc.*

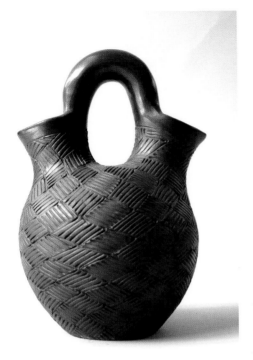

Wedding vase (7.25" x 5.00" x 5.00"). Rebecca Amanda Youngbird. *Qualla Arts and Crafts Mutual, Inc.*

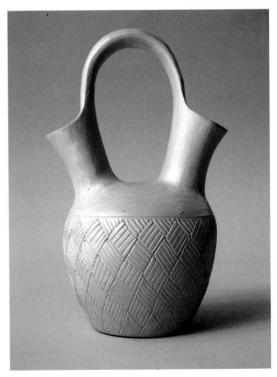

Wedding vase (8.0" x 4.5" x 4.0"). Cora Wahnetah. *Qualla Arts and Crafts Mutual, Inc.*

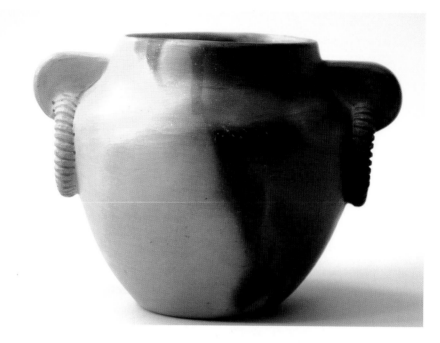

Above: Flame-smoked vase (4.50" x 6.25" x 4.75"). Maude Welch. *Qualla Arts and Crafts Mutual, Inc.*

Below: Flame-smoked vase (5.75" x 5.50" x 5.50"). Maude Welch. *Qualla Arts and Crafts Mutual, Inc.*

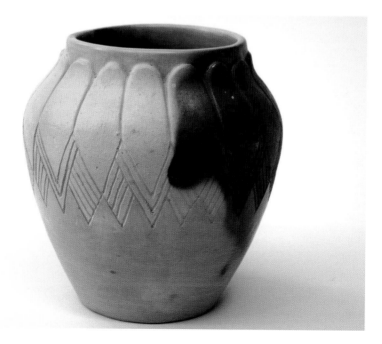

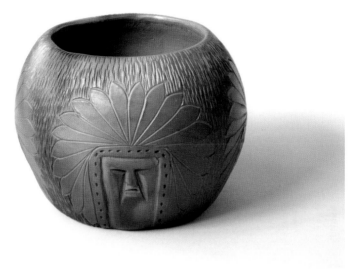

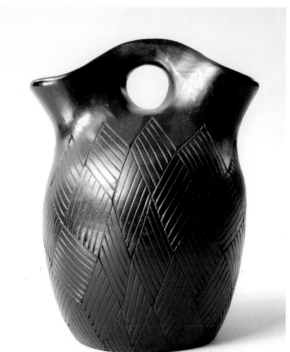

Above: Indian head bowl (4.5" x 5.5" x 5.5"). Elizabeth Bigmeat Jackson. *Qualla Arts and Crafts Mutual, Inc.*

Left: Wedding vase with friendship design (7.25" x 5.75" x 5.25"). Elizabeth Bigmeat Jackson. *Qualla Arts and Crafts Mutual, Inc.*

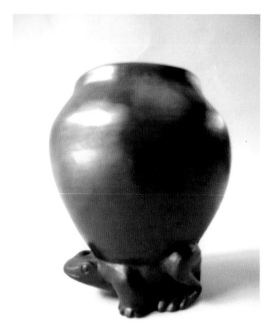

Left: Vase with frog effigy base (7" x 6" x 6"). Mabel Bigmeat Swimmer. *Qualla Arts and Crafts Mutual, Inc.*

Below: Bear paw (1.5" x 5.5" x 6.0"). Made by a member of the Bigmeat family. *Southern Highland Craft Guild.*

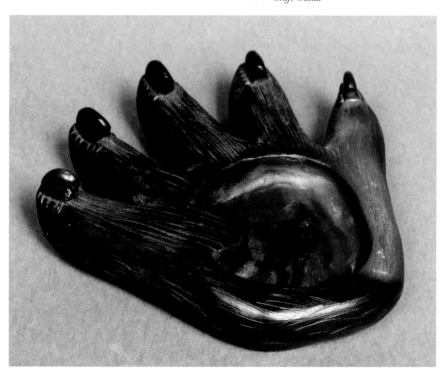

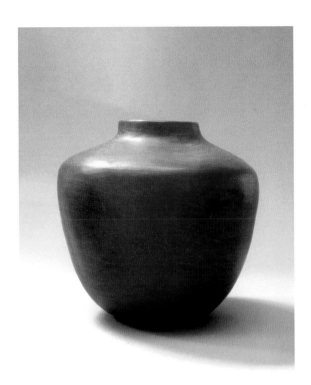

Burnished water jug (8.75"
x 8.75" x 8.75"). Cora
Wahnetah. *Qualla Arts and
Crafts Mutual, Inc.*

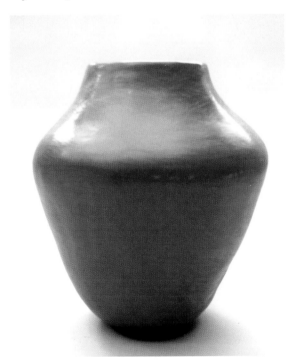

Burnished water jug (11" x
11" x 11"). Cora Wahnetah.
Qualla Arts and Crafts Mutual, Inc.

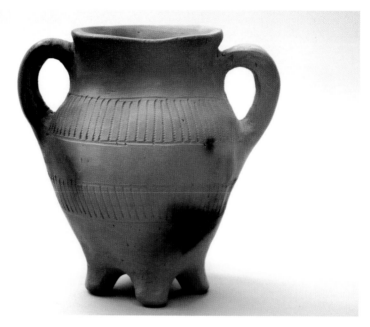

Above: Tripod effigy pot (3.75" x 5.75" x 4.75"). Amanda Swimmer. *Qualla Arts and Crafts Mutual, Inc.*

Below: Handled water jug (7.75" x 8.5" x 5.75"). Amanda Swimmer. *Qualla Arts and Crafts Mutual, Inc.*

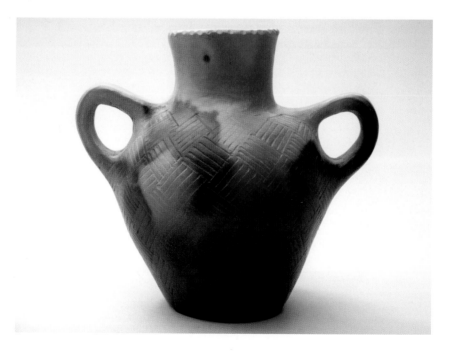

ᎠᎴᎾᏙᏓ ᏚᎳᏧᏍ ᎠᏂᏍᏲᎩᏟᏙᎤᏗ

Gosvnadodi Gadaguga Anigayvli Gegeyonvhi
to.make pottery elders what.they.taught.us

A POTTERY LEGACY

Pottery is the most generally useful in locating vanished peoples and in defining their geographic limitations and migrations. The reasons for this may be briefly stated as follows: first, the need of vessels is common to all mankind, and the use of clay in vessel making is almost universal among peoples sufficiently advanced to utilize it; second, since the clay used readily receives the impress of individual thought, and through this, of national thought, the stamp of each people is distinctly impressed upon its ceramic products.[44]
—W.H. Holmes, 1903

If Susannah and Nettie Owl were Catawba and Lillie Bryson, Rebecca Youngbird and Maude Welch made Catawba-influenced pottery, then who was making Cherokee pottery and what did it look like? Who carried the Cherokee pottery tradition from the close of the nineteenth century into the new "modern" age? To explore these questions and understand the continuity of this tradition, we return to James Mooney's summers in Cherokee and follow M.R. Harrington, another ethnologist, who visited the Qualla Boundary twenty years later.

When Mooney came to Cherokee in the 1880s, he first found Sally Wahuhu and Susannah Owl. Besides these two Catawba women, he observed three other potters who lived near Bryson City in the Birdtown section on the western edge of the Qualla Boundary. Mooney identified them by name: Uhyunli, Katalsta and Iwi Katalsta, all three part of an extended family of pottery manufacturers. By the time Mooney

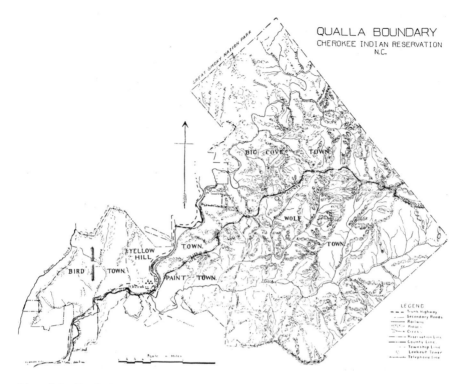

Map of the Qualla Boundary from *The Eastern Cherokee*, 1937. *Hunter Library Special Collections, Western Carolina University.*

encountered the group, two of them—Uhyunli and Katalsta—were quite elderly. Even though Uhyunli was seventy-five and Katalsta ten years older, both were still making pottery. Katalsta's daughter, Iwi Katalsta (he spells her name Ewi), was the youngest of the three, and she was fifty years old. Mooney was impressed to have found a family of potters whose traditions and skills dated back three generations.

A "VANISHED" PEOPLE

Like many culture workers of the time, Holmes and Mooney believed that they were recording the twilight years of a "lost" art practiced by a "vanished peoples." Mooney even began his report with a conclusion: that pottery making among the Cherokee "had fallen into disuse."[45] During multiple visits to the Qualla Boundary, Mooney was able to identify only

a handful of producing potters, but part of the reason for his limited find may have been that his primary purpose was to record stories and myths. There very well may have been other potters that Mooney did not meet. Still, given the times, there was some probable truth to Mooney's statement. Glass containers and tin ware were replacing pottery storage jars. Cast-iron cooking pots and brass kettles were becoming available to all but the most isolated communities, lessening the need for domestically produced pottery. At the turn of the twentieth century, such changes affected local potteries, as their handmade products were replaced by items purchased from the general store. Mooney's statement on the decline of pottery production among the Cherokee was also a reflection of the specific circumstances that befell native peoples. Having arrived on the Qualla Boundary just fifty years after the Cherokee were routed from their homeland, it is any wonder that Mooney was able to find any viable traditions at all.

Another factor contributing to the demise of cultural traditions was the forced removal of entire generations of children to Indian boarding schools. Boarding schools for native peoples were initially set up to "kill the Indian and save the man," a misplaced intention to assimilate indigenous Americans into European culture, as it had become transplanted to the New World. While many native people were eager for an education, schooling came at a high price. In the mid-nineteenth century, the federal government began setting up residential schools and then, in a move all-too reminiscent of federal action prior to the Trail of Tears, children were rounded up and taken away. At school, traditional clothing was discarded and long hair was cut short in an effort to turn the "savage" into a "civilized" being. Dressed in western-style clothing, children were forbidden to speak their native tongue or practice native traditions.

One student recalled his introduction to Carlisle Indian School:

> [Long hair] *was the pride of all Indians. The boys, one by one, would break down and cry when they saw their braids thrown on the floor. All of the buckskin clothes had to go and we had to put on the clothes of the White Man. If we thought the days were bad, the nights were much worse. This is when the loneliness set in, for it was when we knew that we were all alone. Many boys ran away from the school because the treatment was so bad, but most of them were caught and brought back by the police.*[46]

From the 1880s and well into the twentieth century, hundreds of boarding schools were built. Among the better known were Hampton Institute (1861), Carlisle Indian Industrial School (1879) and Haskell Institute, founded as the Indian Industrial Training School (1884). More than 100,000 native children from all tribes—including Eastern Band Cherokees—attended, many against the will of their parents. Scholars are just beginning to examine the trauma and loss of identity that

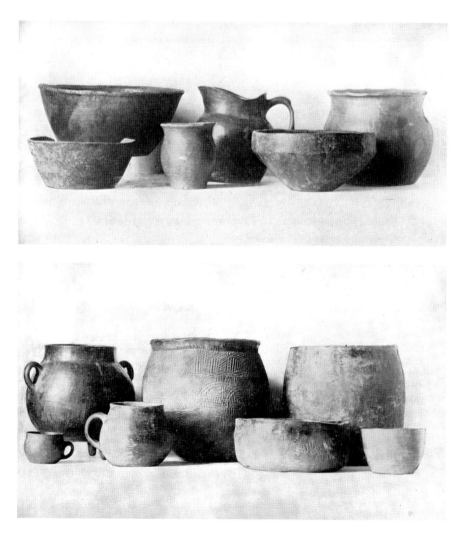

Holmes included this comparison of "modern" Catawba and Cherokee pottery in his report. *Twentieth Annual Report of the Bureau of American Ethnology, 1903.*

resulted from this second "removal" from home and culture. Mooney and Harrington witnessed firsthand this disconnect from tradition.

When Harrington visited some of these same Cherokee potters twenty years after Mooney, he, too, believed that the practice of Cherokee pottery was dying out. Harrington began his study by explaining his intentions and interest in the "survival of the potters' craft among the Eastern Cherokee." Citing Holmes, Harrington made clear that he subscribed to the view shared by Mooney and Holmes: that the craft was in decline. As if to underscore that point, Harrington titled his section of a New York State Museum report, "The Last of the Iroquois Potters." Although the title appears to be a misnomer in the author's application of the term "Iroquois" to a people who are clearly Cherokee, Harrington—like Mooney and Holmes before him—subscribed to the idea that the Cherokee were linked linguistically to their Iroquois forebears, hence the title of his article. The fact that these potters were Cherokee and not Iroquois is not as significant as the fact that Harrington described them as the last of their kind. Both Harrington, and Mooney before him, used this adjective to describe the potters whom they observed on the Qualla Boundary. Mooney's description of the elder Katalsta was as the "last conservator of the potter's art among the East Cherokee."[47] In many ways, both ethnologists were mistaken, but their ideas do hold some merit. At the turn of the twentieth century, the old-style Cherokee pottery made by the Katalstas was giving way to the more "modern" and popular style of the Catawba, although their differences were more a matter of function than production. "Old-style" pottery vessels were largely created for use; modern Catawba-style pottery was made to appeal to a growing tourist clientele.

THE KATALSTA POTTERS

Katalsta (born 1803) was the daughter of an unknown potter-mother and Yonaguska[48] (Drowning Bear), a well-known chief who set the stage for some Cherokee to remain in their eastern homeland. While the specific name of her potter-mother may not be known, Katalsta inherited her potter's skill and her treasured burnishing stone. A significant historical figure, Katalsta could trace her pottery lineage back three generations, meaning that her potter-forebears lived and worked well before removal. Mooney wrote briefly about Katalsta in both his *Myths of the Cherokee* and in his part of Holmes's "Aboriginal Pottery" study. Katalsta was a documented link that

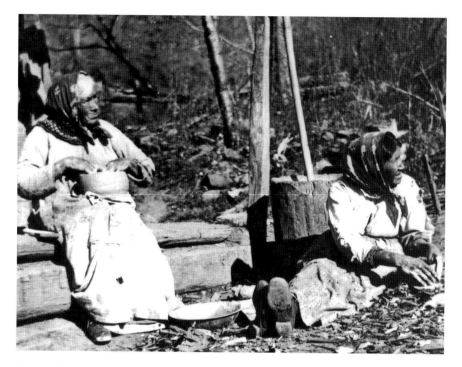

Katalsta (left) and her daughter, Iwi Katalsta, were photographed by James Mooney in the 1880s. Katalsta could trace her pottery lineage back three generations. *Museum of the Cherokee Indian.*

bound together a pottery tradition that bridged the tribal watershed that was the Trail of Tears. Mooney photographed the mother-daughter team of Katalsta and Iwi Katalsta and recorded their methods of working. Unlike other ethnologists, Mooney attempted to learn the Cherokee language to communicate with people that he met.

Mooney was primarily interested in the Katalstas' pottery because he believed it to be authentically Cherokee. The Katalsta family produced a high-quality stamped ware that he claimed resembled archaeological specimens that were specifically Cherokee, rather than Catawba influenced. Holmes made this point in his report (as would Harrington twenty years later):

> *An examination of their modern art in clay develops the fact that they are skillful potters, and what is of special interest is the fact that their ware has several points of analogy with the ancient stamped pottery of the South Appalachian province. Their ware retains more of the archaic elements of form than does that of the Catawbas.*[49]

A Pottery Legacy

Archaeologists and ethnologists have examined excavated clay objects to try to understand the lives of the people who made and used them. They identified gaming pieces, clay toys and a limited number of clay tools. These include paddles made from clay itself but also artifacts like whorls used as weights to increase the speed of a spinner's spindle. For purposes of ornamentation, clay was used to make beads and pendants; for spiritual purposes, it was used to make mortuary vessels, burial offerings and ceremonial pipes. For the most part, clay artifacts were most commonly used for domestic uses: for food preparation, cooking and serving. Traditionally, native potters made round-bottomed cooking pots that could balance in the embers of a fire. Later, with the adoption of tables and hearth cooking, potters made flat-bottomed pots and sometimes added tripod feet to hold pots upright. Large jars were used for cooking, and jugs were used to store water or other liquids. Smaller open-mouthed bowl forms were used for heating and serving food.

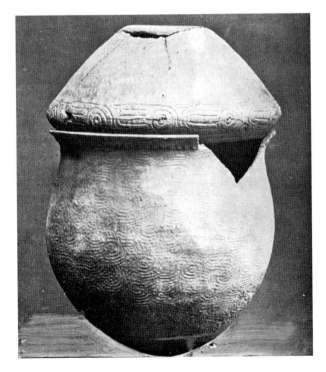

This two-part mortuary vessel was found containing charred human remains. *Twentieth Annual Report of the Bureau of American Ethnology, 1903.*

DIGGING CLAY

While some pottery methods may have been unique to the Katalstas, much of their process follows basic pottery production techniques. Potters throughout the world look for deposits of clay that are free from debris and impurities. Some search far for a particular type of clay as proven by Wedgwood in his eighteenth-century quest. By the early twentieth century, the region was known for its rich sources of minerals, including clay. A regional guide claimed, "Throughout Jackson County, in fact, kaolin is being taken out in immense amounts, the county being famous for its extensive and profitable kaolin workings."[50]

The Katalstas, the Harris-Owls and many twentieth-century Eastern Band Cherokee used clay dug from the north side of Soco Creek. Along Soco Creek, two types of clay were found: a fine-grained, dark-colored clay that was used to make pipes and a lighter gray, coarse clay that was better suited for making cooking pots. These two types of clays were often referred to by their use, "pipe clay" and "pan clay," a sedimentary form of clay also called "blue clay." Pipe clay was more often found on elevated locations; pan clay was usually found on river bottoms and in gullies. The coarseness of the lighter pan clay was due to the natural addition of sand in the clay body. While this gave the material a "gritty" texture, the sand served as a tempering agent, allowing the clay to overcome the stresses caused by drying to minimize shrinkage and warpage. Pipe clay was not suitable for making larger pieces, although it was sometimes mixed with pan clay to produce a workable clay body. Mooney reported that Katalsta preferred the fine dark clay found on Soco Creek, near the old Macedonia mission.[51]

For native peoples, digging clay was a family activity with men and children participating. Clay was sometimes dug by hand; at other times, sticks or hoes were used. The gathered clay was packed into sacks, baskets or boxes and transported home for future use. Like Katalsta, twentieth-century pottery families worked together to gather clay. The entire Bigmeat family went to Soco Creek, a site commonly known for its fine clay deposits. Getting the clay out was still hard work. Louise Bigmeat was the smallest, so she was the one who had to crawl back into the hole to dig out the clay. The family would spend an entire day digging and then pile the clay onto a wood sled pulled by a steer. Before the clay could be used, it had to be cleaned free of debris, adding more time to the process.[52]

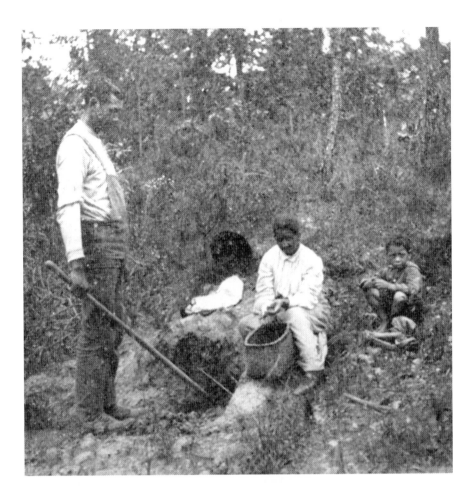

Above: Catawbas John and Rachel Brown working a local clay hole. *Photograph by M.R. Harrington, 1908.*

Left: Kaolin mine in Webster, Jackson County, North Carolina, circa 1897. *Hunter Library Special Collections, Western Carolina University.*

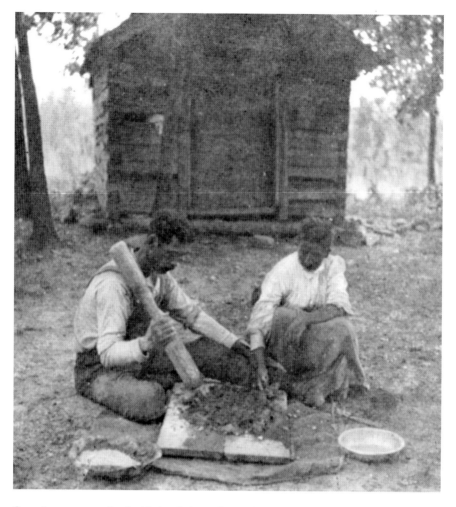

Catawba potters used a double-headed wooden pestle to crush raw clay. *Photograph by M.R. Harrington, 1908.*

These traditional clay pits, whether they were on the Qualla Boundary or in Catawba country, were prized and protected sites. Some were carefully covered to keep the clay from being washed away by rain. Others were guarded or, at the very least, kept a secret. Anthropologist Fewkes was asked to remain in the car while someone gathered a sample of clay for him. At Catawba, where clay deposits were abundant, there was little restriction as to their use. Indeed, the Cherokee made many trips to South Carolina to secure pottery clay. In spite of his being asked to remain behind while

his informant secured a sample of clay for him, Fewkes remarked, "There are no restrictions on the exploitation of the clay beds. Irrespective of land ownership and, apparently, notwithstanding possibilities of trespassing, clay-bearing deposits are free for public use."[53]

Before beginning a piece of pottery, an artisan first had to prepare her clay. Pounding the clay produced a consistent mix and removed air bubbles, which could expand and explode during firing, breaking apart the piece. Catawba potters often used a long, cylindrical double-headed pestle to crush raw clay; Cherokee potter Iwi Katalsta used a hammer stone. The thoroughly mixed clay was sifted, using a household sieve or piece of window screen.

SHAPING CLAY

Some believe that the original use of clay may have been in its "unbaked state," rather than the fired and durable product that is more common throughout history. Certainly, unbaked clay was used as chinking in the walls of log buildings and may have been put to medicinal use. Holmes explained a theory that suggested that pottery originated by accident. "If, as has been suggested, the clay vessel originated with the employment of clay as a lining for cooking pots, or in protecting baskets…from destruction by fire in culinary operations, the clay would…take the form of…the vessel, and the act of molding would be suggested."[54] In other words, an unsuspecting cook may have coated the inside of a basket with wet clay and subjected it to the fire, only to discover that, when cooled, the clay kept its rigid form. This would account for the basketlike impressions found on the exterior of some prehistoric vessels.

At Mooney's request, Katalsta constructed a pot while he watched. He noted that the Katalstas made pottery much in the same way that Catawba potters did. The Catawba and the Cherokee, like other indigenous tribes (and many contemporary potters), used a coil technique for pottery construction. Applying this method, a potter made a thick rope of clay by rolling it between the hands or over a flat surface. The coil was then wound around a clay base to build up the sidewalls of a pot. Looking for things that Katalsta did uniquely, Mooney noted that she began her construction with a single, very long coil and wound it continuously in an upward spiral to build the walls of her pot. This was a slight variation to making several shorter coils and forming them into rings that were the same size as the circumference of the pot being made. Katalsta lifted her finished piece off

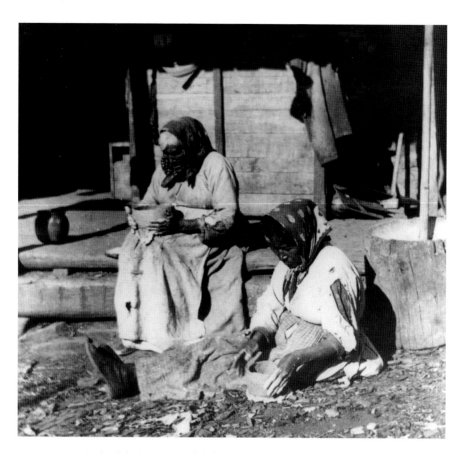

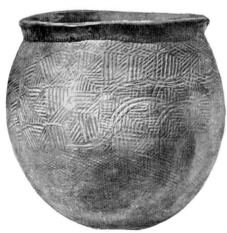

Above: The vessel at left of the two Katalsta potters is similar to one pictured in the Bureau of American Ethnology report. *Museum of the Cherokee Indian.*

Left: Cherokee jar with paddle stamping and notched rim. *Twentieth Annual Report of the Bureau of American Ethnology, 1903.*

its support by means of a cloth. Removing a pot in this manner kept it from becoming misshapen and from damaging the exterior pattern. Holmes commented that this method "prevent[ed] quick drying and consequent cracking of the clay along a weak line."[55] In the few pictures that Mooney made of Katalsta and Iwi Katalsta, the potters are forming their pots on cloth-covered supports. A small finished pot is pictured on the porch next to the elder Katalsta in Mooney's photograph. Its rounded body is necked in, flaring out at its upper rim. This pot closely resembles one collected by Mooney during his 1889 visit to Cherokee. While it is difficult to tell because of the poor quality of the image, the bowl on Katalsta's porch may very well be the same piece he brought back and photographed for the Bureau of American Ethnology report.

A Potter's Tools

Holmes's report on aboriginal pottery included a list of tools identified as part of the potter's craft. Each step in the pottery process required its own specialized tool. Even with specialization, these tools were modest instruments and were often made by the potter herself. A hammer stone, wood club or pestle was used for pulverizing clay prior to construction. Other tools were used to smooth, scrape and compress coils of clay in construction. Catawba potters shaped gourds or shells into a variety of sizes for smoothing and shaping clay pots. In contrast, the Cherokee tended not to use many tools for this purpose. Often they simply used their fingers; Mooney noted Katalsta's use of a household spoon. Many Cherokee potters used a kitchen knife to trim the base and upper edge of their vessels. Perhaps the most common tool in use among native peoples was the polishing stone, often a potter's most prized tool. Catawba and Cherokee potters alike burnished the outside of their pots, using a stone or pebble made smooth by many years of river current. Burnishing the exterior of a pot created a satin patina and compressed the clay. Repeated rubbing with a hard stone closed up the open pores of the clay, adding to its durability and contributing to its ability to hold water. Many a potter noted that her burnishing stone was a prized possession passed from generation to generation, a true heirloom tool. The burnishing stone that Katalsta used had been in her family for three generations.

Once the exterior walls of a pot were smoothed, a potter could add a surface decoration. This was accomplished in different ways depending

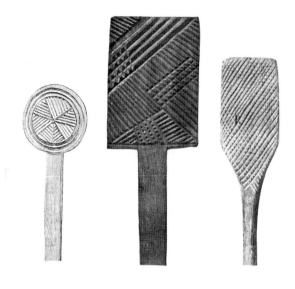

Wood paddles carved with patterned grooves were used to decorate Cherokee pottery. *Twentieth Annual Report of the Bureau of American Ethnology, 1903.*

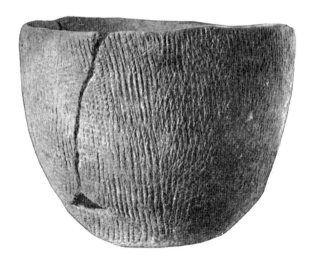

Holmes noted that the surface of this small prehistoric vessel was covered with "markings made by paddling with a cord-wrapped tool." The bowl was excavated from a mound in North Carolina. *Twentieth Annual Report of the Bureau of American Ethnology, 1903.*

upon the desired result. A paddle was used throughout the southern Appalachians and was a hallmark of Cherokee pottery. Holmes classed a number of pottery markings and suggested their origination. He identified the impression of cords that had been wrapped around a paddle. Paddles, made of either wood or clay, were grooved with patterned designs that left impressions on the clay surface when hit. These patterns were often small diamonds, squares, zigzags or circular. Another common tool was a sharpened stick used for incising. Holding her marking stick, a potter made decorative scratch marks in the clay. Catawbas and Cherokees shared some techniques of constructing pottery but departed from each other in their methods of surface decoration. Both traditions depended upon coil construction and neither used a potter's wheel. The Catawbas favored a more highly burnished surface with incised markings, while Cherokee pottery was usually paddle stamped. While in Cherokee territory, Harrington substantiated this subtle difference. He gathered a "fair collection" of specimens varying in size and use and noted that these were "usually covered with stamped designs applied with a carved paddle." Among the pots he collected, "no free-hand incised decoration was seen."[56]

PADDLE STAMPING AND INCISING

Indeed, paddle stamping was a distinguishing characteristic of Cherokee pottery. A potter slapped the pot's exterior repeatedly with a wood paddle carved with a pattern of grooves on its face. While this gentle paddling was decorative, it also enhanced the function of the pot. Such paddling helped to compress the clay, thus strengthening the sidewalls, while simultaneously leaving a soft pattern of overall diamonds or squares on its outer surface. This roughened surface made it easier to keep a firm hold on the outside of a full pot.

A second method of exterior decoration was incising. To create a surface that could accept an incised design, a potter first burnished the pot's exterior with a polishing stone. Once the surface was even, the potter scratched a design onto the smooth surface, using a sharp marking stick. Both methods of paddling and incising were found on prehistoric pottery, were recorded by Mooney at the turn of the century and are used by Cherokee potters today.

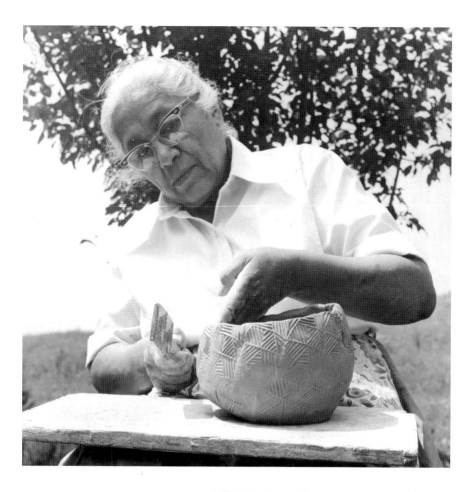

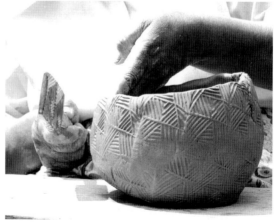

Above: Cora Wahnetah shown demonstrating the process of paddle stamping. *Southern Highland Handicraft Guild Archive.*

Right: A close-up of paddle stamping. *Southern Highland Handicraft Guild Archive.*

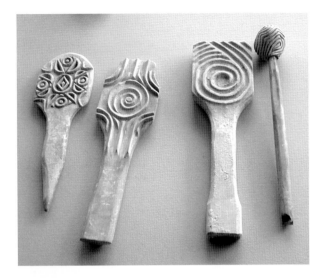

Left: Paddles were made with a variety of carved designs that produced a number of different surface patterns. The contemporary paddles shown here belong to Cora Wahnetah's granddaughter, potter Melissa Maney. *Author's photograph.*

Below: Cora Wahnetah shown demonstrating the use of a patterned paddle. *Qualla Arts and Crafts Mutual, Inc.*

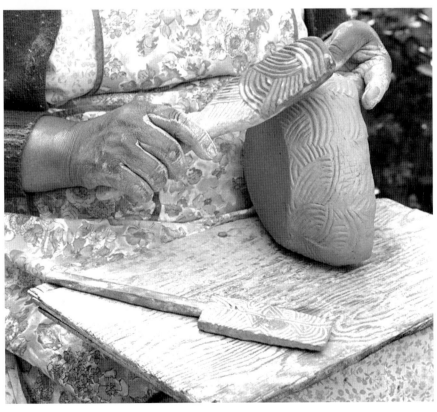

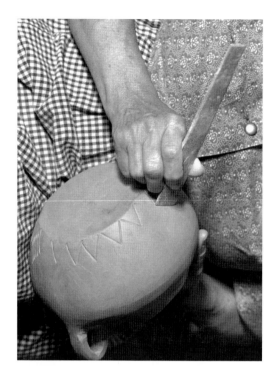

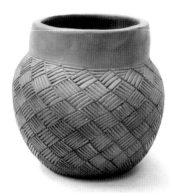

Above, left: Amanda Swimmer shown demonstrating the process of incising. *Qualla Arts and Crafts Mutual, Inc.*

Above, right: A finished pot with deep incising by Cora Wahnetah. *Qualla Arts and Crafts Mutual, Inc.*

FIRING POTTERY

Before firing their pottery, the Katalstas dried their finished pots in the sun and then preheated them beside a hot fire. Once thoroughly dry, the pots were put directly onto the fire and covered with bark. This had the effect of "smoking" the pottery, a process that chemically altered the clay body to produce a dark coloration throughout. Firing is an essential step in the ceramic process, as heat transforms the clay from a fragile material into one that is durable and hard. If clay is fully fired, it achieves vitrification, that is, the clay particles have melted sufficiently to be fused together to produce a product that is waterproof. Traditional pottery was almost always fired, but the firing temperature was not usually sufficient to mature the clay body, leaving it porous and allowing water to seep through. A low-fired pottery

product is not necessarily inferior and, in fact, is sometimes desired. Water stored in a porous clay jar will seep through the vessel walls, evaporate and cool the stored water.

The pit firing method used by Katalsta and later generations of Cherokee potters produced work with mottled surfaces marked by the effect of the flame. Using oak or poplar bark, rather than the hardwood itself, the Katalstas broke the bark into small pieces to produce a hotter fire with less breakage. While a piece was still hot, a potter inverted it over a small hole filled with burning corncobs or meal to "smudge" the pot, a practice that had a long history among the Cherokee. In 1928, prior to the Trail of Tears, one observer described Cherokee pottery as "first hardened by burning, then glazed by the smoke of meal bran." Mooney reported that after half an hour of such smoking, the inside of a pot treated this way was "black and glistening."[57] Blackware pottery and vessels with smudged interiors were noted by ethnologists. Both this method of achieving a black finish and their preference for decorative paddling were considered authentic traits of the Cherokee pottery tradition.

"ᎣᏂ" ᎠᏣᎳᎩ ᏍᎫᏍ ᏗᎪᏍᎥᏀᏍ

Oni Atsalagi Gadaguga Digosvsgi
last Cherokee pottery maker

THE "LAST" CHEROKEE POTTER

Every touch of the potter's hand, of the modeling tool, the stylus, and the brush becomes, through changes wrought in the plastic clay by the application of heat, an ineffaceable record of man's thought and of woman's toil.[58]
—*W.H. Holmes, 1903*

Twenty years after Mooney made his historic visit, M.R. Harrington arrived on the Qualla Boundary to seek out these same Cherokee potters. Harrington came to the Carolinas to collect artifacts for the Museum of the American Indian (Heye Foundation). He spent a month with the Catawbas in South Carolina, where he took note of various pottery forms and the tools used to produce them. He photographed the Brown family at work making pottery. The following month, in July 1908, Harrington traveled west to arrive in Cherokee territory. On Mooney's advice, he sought out Iwi Katalsta (1840–circa 1926) and met a second potter by the name of Jennie Arch. He described Arch as "an aged woman...whose feeble hands had all but lost their skill." Still, fully half the pottery Holmes collected from Cherokee was "said to be the work of her hand," so it is clear that Arch was, in fact, a producing potter. Harrington made no further comments on Jennie Arch nor did he make any pictures of her.[59] By the time of Harrington's visit in 1908, the elder Katalsta had passed away; her daughter was now seventy. Harrington spent the bulk of his time with Iwi Katalsta, documenting her work in words and images in a step-by-step fashion. He arrived at her home in the heart of the Qualla

Iwi Katalsta's home in Yellowhill. *Photograph by M.R. Harrington, 1908.*

Boundary. Katalsta lived in a cabin typical of the region, made of hand-hewn logs and covered with a shake roof. A large stone chimney and fireplace provided its heat.

Iwi Katalsta dug clay from nearby Soco Creek, a place visited by many local potters. Protecting the site of a valued natural resource, Harrington noted that "she did not seem inclined to reveal" the exact location of the clay deposit. Respecting her wishes, he was not able to photograph her digging or transporting clay to her home. His photo essay begins with the potter working on the porch of her home and processing clay for use. She is dressed in a calico print, a common attire of the time, and like almost any photograph of a Cherokee woman at the turn of the twentieth century, she is wearing a patterned head wrap. While the photograph is in black and white, typically these cotton headscarves worn by Cherokee women were brightly colored, wrapped over the hair and tied behind the neck. Also typical of her attire is her white overskirt, a form of female garment that was common to native women and Anglo American settlers alike.

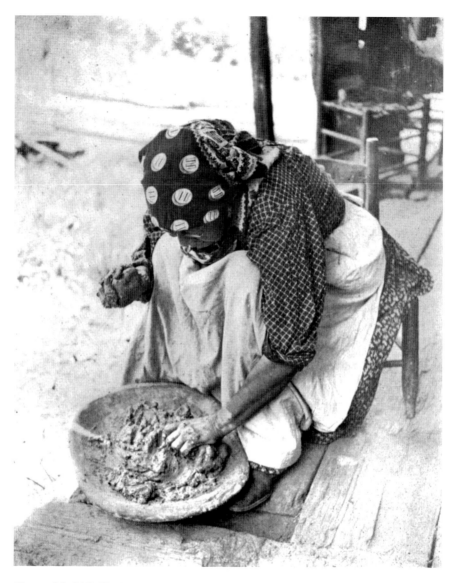

Photograph by M.R. Harrington, 1908.

Harrington's 1909 article, "The Last of the Iroquois Potters," included photographs of Iwi Katalsta pounding clay in preparation for use. The potter is shown bent over a pan of clay with a hammer stone in her hand. Having dug her clay and transported it to her home studio, she began by pulverizing it to a smooth and even consistency. She picked out bits of

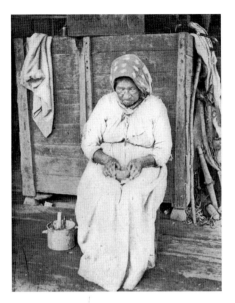

Photograph by M.R. Harrington, 1908.

stone and dirt and then added fine sand as a tempering agent. As most potters understood empirically, sand made the clay less dense and allowed it to dry with less cracking and warpage. Added temper also reduced cracking by facilitating the expansion and contraction resulting from repeated heating and cooling, making the fired clay more resistant to thermal shock. A clay body with added temper—whether added by nature or a potter—was better able to withstand changes in temperature applied during use. Once her clay body was well mixed, Katalsta patted it into a fourteen-inch cake, shaped like a loaf of bread. She dried these cakes of clay and laid them aside for future use.

As a demonstration, Katalsta made a pot for Harrington. She began by making a form today referred to as "pinch" pot. Such a modeled form began with a fist-sized ball of clay and was pinched, using the thumbs and fingers, to depress the center of the ball to form the shape of a small bowl. In this photograph, Katalsta has used the pinch method to form the base of a pot that she will finish by coiling. Harrington tried to engage Katalsta in a conversation about her methods vis-à-vis tradition. When the potter began shaping a bowl on a bit of cotton cloth resting on a common china saucer, Harrington asked her what was used before saucers were available. Katalsta replied—through an interpreter—that small pots were built over gourd supports, but that larger vessels were set into a hole in the ground lined with cloth. Although she had some knowledge of this method, it was not used during her lifetime. Using the evidence that prehistoric pottery surfaces mimicked the woven patterns found on baskets, one theory suggested that this texture may have been the result of a pot's construction within a basket used as a mold. This idea was consistent with Katalsta's recollection. Always interested in learning more about old-style pottery, Harrington requested that Katalsta make her demonstration pottery using a gourd rather than her china saucer.[60]

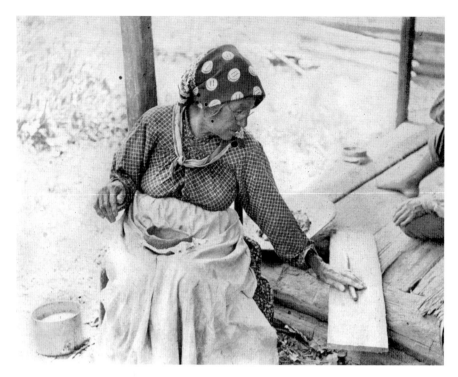

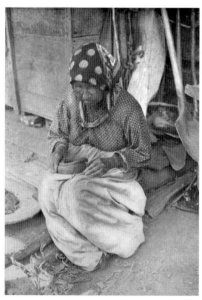

Photographs by M.R. Harrington, 1908.

Many native tribes, including the Cherokee and Catawba, make pots using the coil method. In this photograph, Katalsta demonstrated the steps in this process. With the pinched base of her pot resting in her lap (presumably resting on a gourd rather than a china saucer), Katalsta rolled out a coil of clay using her left hand. To her right is a pan of water, ready for use as a wetting agent. She will continue to roll additional coils to add to the wall of her bowl and will use the water to help fuse the coils together.

In this photograph, Katalsta began to build up the sidewalls of her pot. She had carefully laid a rope of clay along the upper edge of the

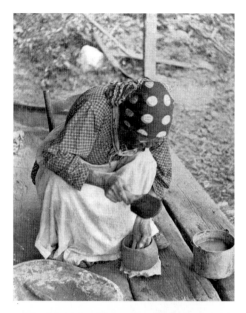

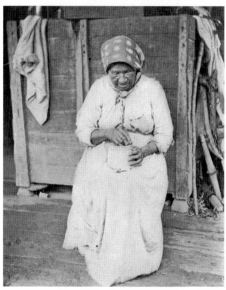

Photographs by M.R. Harrington, 1908.

modeled base. Using her thumb on the inside of the pot, she pressed the coil onto the base to create a secure join. Harrington observed that Katalsta set each subsequent coil just inside the other rather than directly on top of the previously laid coil. This method added strength to the overlapping coils.

Katalsta demonstrated her use of a stamping paddle on a shaped pot using a wood paddle carved with grooves. She was careful to hold the inside of the pot with one hand as she paddled the outside to produce an overall pattern on the vessel's exterior surface. This step not only had the benefit of adding a decorative element to the clay but also served to compress the sidewalls, securing the coils one to the other.

Katalsta has added a lip to the upper edge of her finished pot, creating a reinforced rim. Her finger marks are visible around the upper edge. Cherokee potters often paddle stamped their work and finished off a pot with this type of added rim. Such a rim reinforced the upper edge of the pot and helped to prevent chipping during use. The rim was sometimes decorated with notches, dots, simple lines or sometimes left plain.

Katalsta has smoothed away her finger marks to create a pottery form with a rounded body and flared lip, a traditional shape repeated generation after generation. Twenty years earlier, James Mooney photographed Iwi

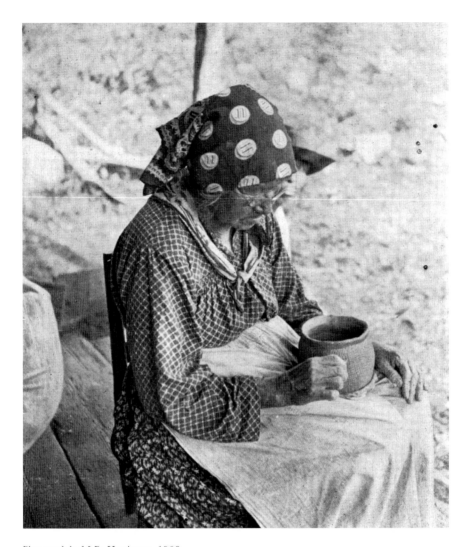

Photograph by M.R. Harrington, 1908.

Katalsta and her mother with a finished pot on the porch beside them. That pot from the 1880s—and this one made twenty years later—are similar, demonstrating the enduring forms of traditional pottery. Iwi Katalsta used a sharp stick to make decorative marks on the exterior of her pot. Harrington remarked that she "used no tools except the paddle, the marking stick, and her fingers." This seemed "remarkable" to him, "in view of the numerous smoothing tools of gourd, shell and wood employed by the Catawba." The demonstration well illustrates the economy of Iwi Katalsta's technique.

The "Last" Cherokee Potter

Photographs by M.R. Harrington, 1908.

Katalsta allowed her pots to dry for a few days before subjecting them to the fire. As any potter will learn, pottery that contains moisture will break apart in the firing, so thorough drying is a critical step. Katalsta finished drying her pots by first propping them around a fire with their open end toward the blaze. Afterward, she inverted them over the embers.

Katalsta covered the preheated clay vessels with bark and wood. An hour later, the bark had burned away, leaving the pots protruding through the ashes. With a long stick, she raked them out and tapped them to test for cracks. A cracked piece produced a dull thud, while a solid pot would ring true. She finished off this process by "smoking" her pottery, dropping a handful of bran or corncobs into each pot.

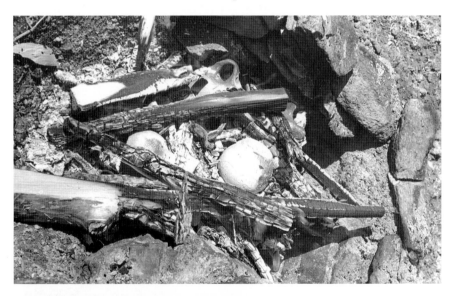

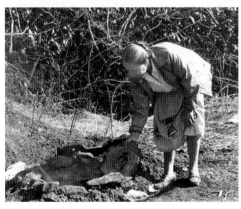

The firing process used by contemporary potter Amanda Swimmer is traditional, following the same process used by Iwi Katalsta much earlier in the century. *Qualla Arts and Crafts Mutual, Inc.*

The "Last" Cherokee Potter

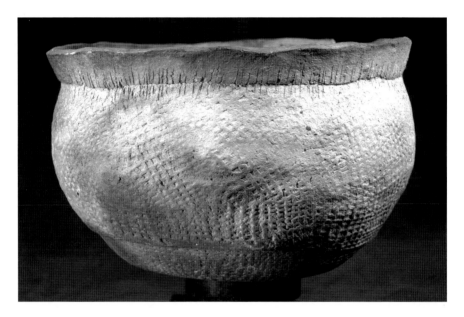

Edward Valentine collected this pot made by Iwi Katalsta in 1885. Fewkes referred to her pottery as the "last flickers of the now vanished Cherokee...traditional expression." *Research Laboratories of Archaeology, University of North Carolina at Chapel Hill.*

A large open jar, collected by Edward Valentine in 1885, is believed to have been made by Iwi Katalsta. It is a good example of a vessel that Harrington would call old-style Cherokee ware. Its base is rounded. Its sidewalls swell outward before tapering in. An added rim is marked with repeated notches. Overall, its exterior is paddle stamped to exhibit a soft patterned surface. Archaeologist Brett Riggs noted that Harrington recognized a direct continuity between Katalsta's old-style wares and the archaeological ceramics found in local mound and village sites in the North Carolina mountains. He connected Harrington's work to contemporary archaeology. "Archaeologists now characterize Katâlsta's wares as part of the Qualla ceramic series."[61]

Harrington was certainly aware of the differences between old-style Cherokee pottery and the more modern Catawba-style ware. He had visited the Catawba in June 1908 before traveling to Cherokee territory in July. He summarized his observations of Catawba pottery with a statement that their pottery exhibited "very little Indian character in form or design" and that "ancestral patterns [had] been sacrificed to the demands of the trade." He concluded his article with this observation about Cherokee pottery. "The Eastern Band of Cherokee in North Carolina still boasts a few old potters but

owning to the lack of demand for their product, the art has been practically abandoned…But, as I say, the ceramic art of the Cherokee is dying, while the other Eastern tribes retain little more than vestiges and memories."[62] As we will see in the following pages, Harrington's conclusion was hasty at best, and that the practice of Cherokee pottery continued to grow throughout the twentieth century to take a surprising twist in the twenty-first.

ᎬᏃᏓ ᏴᏫ ᎤᏁᏤᎵ ᎦᏓᎫᎦ

Gvnadena Yvwi Unatseli Gadaguga

everywhere people their pottery

Pottery for the Public

We, the undersigned members of the Eastern Band of Cherokee Indians, do voluntarily associate together to promote our social welfare in the economic field by forming a non-profit arts and crafts association; also to develop a program for retaining the heritage of our tribe.
—*Qualla Arts and Crafts Mutual, Inc.*

While ethnologists came to the Qualla Boundary in a slow but steady stream during the late nineteenth century, a swell of curious visitors began arriving by the start of the new century. By this time, the railroad had established several passenger routes into the region, making it easy to hop on a train in New York City or Washington, D.C., and get off in Asheville, a city tucked in among North Carolina's mountains. In the decades spanning the turn of the century, Asheville became a tourist mecca offering healthful mountain retreats, church "camps" and scenic beauty. Its population more than quadrupled, from two thousand to ten thousand within a few short decades. From Asheville, the Southern Railway branched out to the west, taking travelers along the southern edge of the Great Smoky Mountains. Train depots were located in the many small towns along the way, more than twenty-five of them between Asheville and Murphy, a distance of just over one hundred miles. Passengers could get off in Dillsboro or Whittier, where they had the best access to the Qualla Boundary.

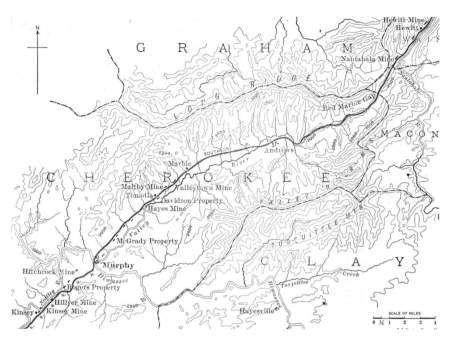

The Southern Railway line is seen cutting diagonally across this map from a 1900 publication on mineral deposits in western North Carolina. *Hunter Library Special Collections, Western Carolina University.*

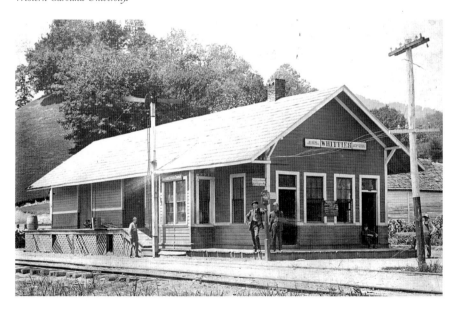

A dozen small railroad stations, like this one at Whittier, provided service to rural mountain communities. Whittier is located south of the Qualla Boundary. *Hunter Library Special Collections, Western Carolina University.*

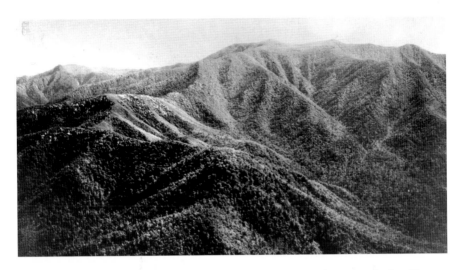

The Great Smoky Mountains inspired visitors, photographers and conservationists. *Hunter Library Special Collections, Western Carolina University. Used with permission from Thompson Photo Products; photograph by Thompson Brothers.*

Good inns and boardinghouses could be found in Dillsboro as well as at other stops close to Cherokee, including Whittier and Bryson City. From various points along the way, a visitor could take a stage or hop on one of the smaller spur lines that cut more deeply into the mountains. By 1910, the Appalachian Railway Company operated a seven-mile spur line from Ela into Cherokee, linking the Qualla Boundary with routes along the Southern Railway to the west and to Waynesville and Asheville to the east. A local newspaper announcement pointed out the broader implications of this rail extension. "The railway is of more than local importance because it passes through vast virgin forests up the Ocona Lufty river and affords wonderful views of mountain scenery, views hitherto unknown to the public because of the inaccessibility of the view points. Many people will be glad to travel over it simply for the scenery."[63]

A NATIONAL PASTIME

Within a few decades, the heyday of rail travel was eclipsed by the invention and rapid popularization of the automobile. As more cars were made and sold, more roads were needed to accommodate them. But in 1904, in its first census, the Federal Office of Public Roads counted only 100,000 miles

Auto travel brought tour buses into downtown Cherokee, giving visitors an alternate means of travel into the Qualla Boundary. *North Carolina Archives; North Carolina Department of Tourism photograph by John H. Hemmer.*

of paved roads, a mere fraction of the 3,000,000 road miles in America today. Still, motoring was quickly becoming an American pastime with enthusiasm demonstrated by the country's top leadership. President Woodrow Wilson was an avid motorist, but his interest in good roads went beyond sightseeing to the idea of creating a national American culture. His sentiment was captured in his words inscribed on a bridge that bears his name. "My interest in good roads is not merely an interest in the pleasure of riding in automobiles…it is also the interest in weaving as complicated and elaborate a net of neighborhood and state and national opinions together a it is possible to weave."[64] Tourists now had multiple ways to enter the heart of Cherokee territory and experience the tapestry of Appalachian mountain communities. Thus, the automobile and tourism began to shape a national audience for a previously localized culture.

In the fall of 1932, Franklin Delano Roosevelt was elected with a promise to give American citizens a "new deal." FDR's New Deal programs were broad, encompassing Social Security and rural electrification. Within weeks of his inauguration, he began to form the Civilian Conservation Corps (CCC), his "Tree Army." The CCC was conceived as an employment program focused on conservation and construction. In spite of the Great

President Franklin Delano Roosevelt traveled through western North Carolina. In 1936, his motorcade drove along the main street in Sylva, a town to the east of the Qualla Boundary. *Hunter Library Special Collections, Western Carolina University.*

Depression—and in part because of it—Roosevelt used the CCC to build two of the country's most popular national treasures, the Great Smoky Mountains National Park and Blue Ridge Parkway. The opening of the Great Smoky Mountains National Park in 1934 focused a national spotlight on the region and expanded the audience for Cherokee culture. The Blue Ridge Parkway had equal impact. With its northernmost point in Virginia, the parkway wound travelers along a 469-mile route, taking them to Cherokee at the parkway's end. The fact that the parkway and national park skirt the Qualla Boundary may not have been a coincidence. There were those who suggested that the Cherokees might serve as "one of the interesting features of the Park." The idea that the park would forever impact life on the Qualla Boundary was recognized even before the park was complete. Henry M. Owl, writing in 1929, said that the park "will increase the Indian's chance each year for better and bigger sales for their handicrafts."[65]

CULTURE ON PARADE

As travel into and out of Cherokee became easier, new venues let tourists spend more time there. The Cherokee Indian Fair became a popular attraction, and tourist shops began to spring up along the main street of town. One unintended result of this rapidly expanding tourist base was a rush to fabricate "traditions" that appealed to the incoming audience. Unfortunately, for those who wished to observe genuine culture, the served-up variety more closely resembled a Hollywood-style cowboys and Indians stage set. On the streets of Cherokee, enrolled Eastern Band member Henry Lambert regularly performed as an "Indian chief," wearing the full regalia of a western feathered headdress. While certainly not authentic to Cherokee culture, Lambert defended his role as "chief" by explaining, "Ninety percent of the tourists who come here look for Indians who live in teepees and run around naked and hide behind trees and ride horses." While this outsiders' view of Cherokee culture was distorted, it certainly did draw crowds. Lambert recalled the "heyday" of visitation in the 1950s, 1960s and 1970s, when "cars were bumper to bumper through the whole town." Writing about the effects of tourism on private life, scholar Christina Taylor Beard-Moose posed the question, "Does mass tourism perpetuate…the 'us' versus 'them' mind-set that continues to be taught to American children through public education? Or is tourism in the business of educating the public about unique indigenous histories?"[66]

Cherokee potters were quick to respond to market opportunities provided by the growth of tourism. With few established storefronts—and before the creation of a tribal arts and crafts guild in the 1940s—potters either carried their work to neighboring towns and resorts or sold directly from their homes. There are many accounts of basket weavers walking from Big Cove into Cherokee or Waynesville to sell baskets, but pottery was much heavier—and breakable—so this method of selling was not a viable option for potters. An additional detriment to sales for any Cherokee craft was the harsh winter weather when mountain roads were not even passable. The weather limited the opportunity for artisans to sell their wares to the summer-season visitors. Still, the market for pottery continued to grow, which encouraged its production. Because local potters could not keep up with demand, work was still purchased from the Catawbas who were happy to bring their product to Cherokee by car. Some traders even traveled to South Carolina to pick up a supply.

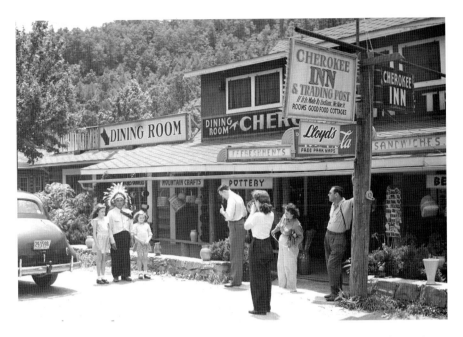

Families visited Cherokee in great numbers, sometimes buying authentic Cherokee crafts and sometimes enjoying more fictitious "traditions." *North Carolina Archives; North Carolina Department of Tourism; photograph by John H. Hemmer.*

An increase in the number of craft and seasonal fairs presented new opportunities for potters. The Cherokee Indian Fair and the Craftsman's Fair of the Southern Highlands were two regional events that drew visitors and buyers from great distances. The Cherokee Indian Fair first opened in 1914 and has been an annual autumn event ever since. Big Cove residents, including Will West Long, mask maker and keeper of Cherokee cultural traditions, proposed to hold a fair on the grounds of the Cherokee Agency. In collecting remembrances of that first fair, Mary Ulmer Chiltoskey recorded fond memories of merry-go-rounds and ice cream. Goingback Chiltoskey recalled that his mother, Charlotte Hornbuckle Chiltoskie, demonstrated basket weaving at one of the first fairs. Pictures taken at that first fair show off pottery that was all of the Catawba-type, miniature pots that were suitably sold as souvenirs.[67]

The Cherokee Indian Fair quickly became a popular event with announcements included in various travel reviews. A 1935 article in a neighboring newspaper noted that fifteen thousand visitors attended the fair throughout its four-day run. Of particular interest to local promoters

Like many Cherokee craftsmen, Maude Welch sold work from her home. A sign in front of her house reads: "Indian pottery made—sold here." *Museum of the Cherokee Indian.*

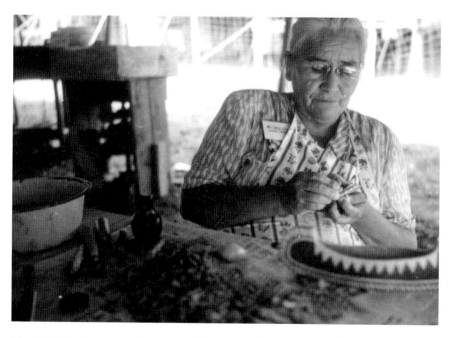

Maude Welch demonstrated pottery making at one of the first fairs established by the Southern Highland Handicraft Guild. She is shown here working at the 1949 fair when it was held in Gatlinburg, Tennessee. *Southern Highland Handicraft Guild Archive.*

The annual Cherokee Indian Fair was a showcase for crafts and agricultural harvest. *North Carolina Archives; North Carolina Department of Tourism.*

was the fact that fully half the cars were from outside the region. The fair did, indeed, attract attention from afar. A 1938 special to the *New York Times* ran in July, giving metropolitan readers time to make plans to come to the festival that fall. The fair also provided a new venue for cultural display. The tribe's first pageant, *Spirit of the Great Smokies*, made its debut at the 1935 fair. The pageant included over two hundred actors and heralded the coming of Cherokee's enduring and popular drama, *Unto These Hills*. The growth of the fair's audience is indicated by the program advertisements. In the 1950 program, one store declared

itself the "Headquarters for Eastman and Ansco Film Supplies—All sizes and color." Such advertisements well illustrate the fact that the fair had become a spectacle for visitors. By 1950, the Cherokee Indian Fair program included photographs and an overview of "Indian Arts and Crafts." A section on pottery included this interpretation:

> *There is a continuous tradition of pottery making among the Cherokees. Not more than a generation ago Cherokees still used pottery vessels for cooking, and few families still have cooking pots of pottery which bear the marks of the flames and smoke from the hearth fires where the cooking was done. Cherokees no longer cook in clay vessels and for quite a while little pottery was made. Only three potters were on the reservation in 1890. Since a rather recent revival of the craft, Cherokee potters are consciously attempting to make their wares as much like the ancient Cherokee pottery as possible.*[68]

A CRAFT REVIVAL

The "rather recent revival" of craft noted in the 1950 Cherokee Indian Fair program referred to a revived interest in handmade traditions that had swept the entire Appalachian region during the preceding twenty years. This included the formation of a number of crafts schools, craft-producing centers and a regional guild. Established in 1930 as the Southern Mountain Handicraft Guild, the Southern Highland Handicraft Guild (SHHG) encompassed a membership from nine states. The Cherokee joined the cooperative marketing operation in 1936. From the guild's start, Eastern Band craftsmen participated in occasional exhibitions and annual fairs. The first Craftsman's Fair of the Southern Highlands was held in July 1948 in Gatlinburg, a mountain resort community within an hour of the Qualla Boundary. Showing at that first fair was Cherokee potter Charlotte Welch Bigmeat. Goingback Chiltoskey demonstrated woodcarving, and Lottie Stamper made baskets.

Education was a strong component of the craft revival, with several schools forming during the first decades of the twentieth century. In western North Carolina, the John C. Campbell Folk School opened in 1925, and the Penland School of Handicrafts was born in 1929. By the 1930s, the Cherokee boarding school was adding courses on Cherokee crafts. Maude Welch taught pottery in 1934, replaced by Bettie Welch

Smith who began the following year. Goingback Chiltoskey taught furniture making and woodcarving, and in 1937, Lottie Stamper began teaching basketry. The crafts curriculum at the Cherokee boarding school was split along gendered lines; weaving, pottery and basket making were part of home economics. Furniture making and woodcarving were part of a male-centered vocational coursework that included forestry, agriculture and auto mechanics. Still, there was not a strict gendered division; boys could take homemaking as an elective, while gardening and poultry raising were part of the girls' home economics classes.[69]

Even before the implementation of the government's infamous "civilization" programs, weaving was promoted in an attempt to anglicize native crafts. Both weaving and its sister process, spinning, were predominant activities for women settlers. "Cherokee girls should be taught to spin, weave, and sew," read an official 1816 directive with instructions to build a school outfitted with "a loom and half a dozen spinning wheels." Such agendas undermined Native American traditions and favored loom and textile weaving over similar indigenous crafts, like basket weaving. The twentieth-century inclusion of Cherokee crafts as part of the school curriculum was a turnabout from older school policy in which schools actively (and notoriously) sought to extinguish native practices from their educational programs. Such teaching, however, was not without its drawbacks. In 1931, weaving was introduced into the curriculum at the Cherokee boarding school. While craft classes were later taught by talented Eastern Band craftsmen, weaving was taught by Ethel Garnett, a graduate of the well-regarded Berea College weaving program. Apparently, Garnett was not a promoter of authenticity or tradition. In a news interview, she explained, "Through the influence of the white settlers, improvement was made in [Cherokee] weaving." In spite of such prejudice, Garnett built a weaving program that appeared to thrive, boasting twenty looms. Her statement that "ten women spend all their time here weaving and I have thirty-five girls in my classes" implies that the looms may have had a dual purpose in their use by both students and local women alike. This was likely the case, since Garnett learned her craft at Berea College where such town-gown collaborations were commonplace. Because the weaving program was inventive, it had no problem adding new designs and patterns. Roxana Standingdeer Stamper wove a new pattern known as "Road to Soco." When the pattern was exhibited at the 1939 San Francisco World's Fair, "its fame spread far and wide."[70]

During the time that the in-school Cherokee crafts program was aligned with home economics, its development benefited from an infrastructure

that included the educational system and agricultural extension. This allowed for craft education to reach beyond the classroom via programs in which local women got to use school looms in exchange for a share of their output. In Cherokee, extension supported fourteen different women's clubs "doing home industries," which included "spinning, carding, dyeing with natural dyes, rug making and basketry." One positive contribution was Garnett's interdisciplinary approach to the program. The wool she needed for weaving was grown locally, and the spinning and dyeing were done at the Snowbird Indian School at Robbinsville.[71] The issue of sustainability that plagues us today could be ameliorated by this type of integrative model. Placing craft process at its center, the weaving program fostered home husbandry and school-based industry that benefited students and their families.

Several period documents well illustrate the pressures exerted on the tribe by outside forces, and it depended on one's perspective whether such changes to the school curriculum were seen to have positive or negative implications. In 1935, Raymond Stites, a university professor with an interest in Native American material culture, made arrangements with the Cherokee Indian Agency to spend a summer on the Qualla Boundary. Once there, Stites made a survey of craft shop owners to determine ways to improve the sale of local pottery. "No one suggested that the design might be improved," he wrote, but the "majority of the storekeepers suggested that if only the pottery could be made to hold water, it would be worth twice as much." So, Stites focused on constructing kilns that would raise the temperature of the pottery firing to improve the vitrification of the clay. Working with pottery teacher Bettie Smith, Stites built a kiln behind the school's home economics cottage where pottery was taught. Ironically, the construction of these kilns caught the attention of the press and was even reported in the *New York Times*. But not everyone shared the enthusiasm. Confronted by the suggestion that she build a kiln, potter Ella Arch "viewed [the project] with alarm." In spite of local opposition, several non-Cherokee elements were added to the arts and crafts program. Potter's wheels were introduced through a combination of family and political connections, as was slip molding, an industrial ceramic process adopted on a smaller scale.[72]

One aspect of the craft revival was its renewed awareness of preserving and maintaining culture, an interest held over from the scholarship of "vanishing" peoples in the nineteenth century. Curator Allen Eaton, educator Olive Dame Campbell and SHHG president Clem Douglas

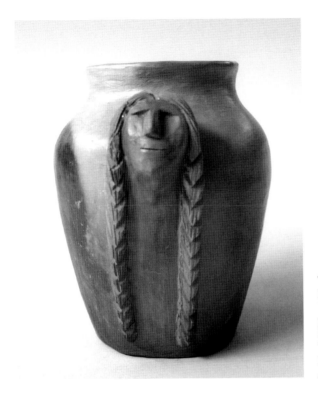

This vase was made by Bettie Welch Smith (circa 1876–1975) who taught pottery at the Cherokee boarding school. Maude Welch was her sister-in-law. *Qualla Arts and Crafts Mutual, Inc.*

all subscribed to this notion. But this idea was not an exclusive of Euro American culture, and indeed, several tribesmen shared in this desire. Stites reported that the Cherokee were "anxious, because of tribal pride, to find the true Cherokee style and to eliminate pottery…which had shapes peculiar to the Catawba." The Cherokee Indian Fair program proclaimed, "Cherokee potters are consciously attempting to make their wares…like the ancient Cherokee pottery." This statement is an indication that Eastern Band craftsmen and tribesmen were examining their own traditions with new interest. There was some attempt to add an element of research to support a more authentic approach to craftwork. One source for Cherokee material was a collection owned by Burnham Colburn, whom Stites regarded as a "connoisseur of Indian pottery." Colburn appeared generous with his collection. He gave photographs of Native American artifacts to the Cherokee Agency and hosted a group of craft teachers at his "museum." Colburn's collection of native baskets and pottery was used as reference material in the classroom. Not everyone was pleased with the intrusion of so many outside culture "experts." Stites remarked that in sharing his project with "visitors and

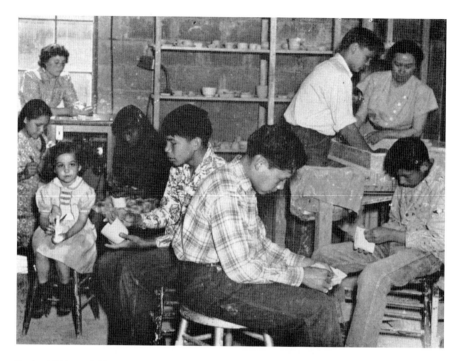

In the 1930s and 1940s, courses in handcraft traditions were taught in Cherokee schools. *Museum of the Cherokee Indian.*

critics," there were "several of the latter." Indeed, Stites raised the ire of none other than Will West Long, the tribe's cultural patriarch. A few years later, the project was labeled an "abortive endeavor." A 1945 article characterized Stites as a "wandering art teacher" who "made an abortive attempt to introduce casting and designs from the Southwest!" The author described the project as "another instance of the futility of selecting traits for transplantation because they are "Indian."[73]

INDIAN ARTS AND CRAFTS BOARD

The modern trend to include traditional crafts in the high school curriculum had been part of a change in attitude that began with the passage of the 1935 Indian Arts and Crafts Act. The act established the Indian Arts and Crafts Board (IACB) and placed it within the Department of the Interior under Harold Ickes, the same secretary who oversaw

construction of the Great Smoky Mountains National Park and Blue Ridge Parkway. The board was charged with "promot[ing] the economic welfare of Indian tribes…through the development of Indian arts and crafts and an expansion of the market for the products of Indian art and craftsmanship." During its first decade, the Indian Arts and Crafts Board worked almost exclusively with southwestern Indian tribes. Its work in the southeast did not truly begin until after the war. This was surprising since the commissioner of Indian Affairs, John Collier, had strong southern roots. Given its national, if not international dimension, the Indian Arts and Crafts Board enjoyed a steady stream of funding and political power. Some of its influence translated into national exposure for Native American artists. In 1936, Rene d'Harnoncourt was appointed general manager of the Indian Arts and Crafts Board. The son of a Viennese count, d'Harnoncourt worked as an antiques dealer before his association with IACB and his later appointment as director of the Museum of Modern Art. In 1941, he curated *Indian Art of the United States*, a prestigious exhibition of native arts. Recognizing the deep roots of native arts and crafts, he labeled them "the oldest and most American of any we have in this country." Still, while the influential exhibition intended to illustrate the breadth of native traditions from coast to coast and featured many wonderful objects, the Cherokee were woefully underrepresented. More problematic than this lack of representation was the premise that traditional crafts could be repurposed to become useful items in a contemporary home environment and appeal to upscale consumers. D'Harnoncourt remarked, "The modern Indian can produce artistic things whose beauty and utility are keyed to modern life." Thus, it was under the IACB umbrella that Cherokee storage baskets became "waste" baskets and ceremonial pottery forms became "ashtrays." This reattribution of function devalued the meaning of indigenous cultural objects by assigning mundane functions to forms with potential spiritual and cultural significance.[74]

Locally, the Cherokee crafts community did enjoy a measure of collective representation and exposure that dated back to the construction of a new council house in 1934. Under the direction of newly elected principal chief Jarrett Blythe, when the new council house opened, it included a room set aside for arts and crafts display and sales. While the sales room represented a commitment on behalf of tribal council, its opportunities were limited by the fact that the shop was only open during the summer months, leaving craftsmen with no outlet in winter. This

Cherokee "chief" dressed in a western-style headdress. *North Carolina Archives; North Carolina Department of Tourism; photograph by John H. Hemmer.*

may have been sufficient for some makers, who were able to plan ahead to create a stockpile of items during the off season or for those who only produced a limited quantity. But for most, creating a year-round market for their work was a priority for arts and crafts expansion. In addition to the council house sales shop, Stites counted five commercial outlets: "Lloyd's Log Cabin, McLean's Trading Post, Tahquette's Store, Duncan's Store…and Mrs. Owl's Shop." While most of these sold authentic baskets and pottery, they also rounded out their inventory with "bric-a-brac" to appeal to the "casual tourist." Stites criticized the council house gallery, claiming that its stock was dominated by a single family and that its ambiance lacked "atmosphere."[75]

In the mid-1940s, Cherokee Agency superintendent Joe Jennings brought together a local group of craft supporters to announce that Charles Collier was interested in "greatly extending the Arts and Crafts" on the Qualla Boundary. Collier was the vice-president of Georgia Power and the brother of Commissioner John Collier. The assembled group included Chief Blythe, weaving teacher Lottie Stamper, craft instructor Ethel Garnett and home economics supervisor Gertrude Flanagan. These opening conversations began building a constituency that led to the

development of a successful artisan guild on the Qualla Boundary. When Joe Jennings began hosting regular meetings to discuss the situation for craftsmen on the Qualla Boundary, the group soon discovered that there was little information to go on. They posed several rhetorical questions. "What is the normal or potential capacity for Arts and Crafts?" they wondered. In the course of the meeting, someone suggested that a survey be taken to determine just how many craftsmen were working on the Qualla Boundary at the time. Committees were set up to count the number of articles produced in each community and to determine the approximate revenue obtained from their sales. The actualized survey included a tally of crafts listed community by community and, unlike many documents from this period, included the names of individual makers. From this survey, it is easy to understand why many shared the belief that Cherokee pottery was in decline. Basket weaving certainly predominated, accounting for more than half the crafts counted. There were 134 basket weavers, 44 listed as weavers, 19 bead workers, 22 wood workers, 22 spinners and just 19 potters. Not surprisingly, several meetings focused on basketry, suggesting types and prices for particular baskets. There was a concern that there were not enough basket weavers who made cane baskets and that others were using commercial dyes on white oak. As the "reorganization of the Craft Work" went forward, they considered starting a pilot program. Could they get a dozen basket weavers "to sell us all of their baskets?" The group brought up the idea of forming an "Arts and Crafts association" that could buy crafts outright. Other ideas centered on improving the availability of material resources, like cane and yellowroot. Sometimes meetings brought up various issues impeding the growth of crafts. Jennings suggested that the ECBI develop a "trade mark" to indicate to a buyer that an item was authentically Cherokee. While there was no specific action taken on several of these suggestions, it is obvious from the meeting minutes that the group began to mentally draft a mission and longer-term agenda.[76]

Throughout these discussions, it seemed as though the group presumed that any expansion of craft production would be based on traditional methods. While this was a lofty ideal, it was not always supported by individuals within the group. The block of Bureau of Indian Affairs–appointed teachers was professionally educated, but they knew little about Cherokee methods. Gertrude Flanagan had a master's degree in home economics and had written a thesis "on Indian work." Originally hired to teach home economics, once on site, she received a mandate

CHEROKEE INDIAN
HANDICRAFTS

BASKETS
WEAVING
POTTERY
WOOD CARVING
METAL WORK
RUGS — BRAIDED & WOVEN

CRAFT SHOP
Boundary Tree Development
N. C. 107 at Smokies Park Boundary
CHEROKEE, NORTH CAROLINA

One of the goals of the Indian Arts and Crafts Board was to establish standards for craft products that would demonstrate authenticity. From its earliest days, the Qualla Arts and Crafts cooperative created a logo and tag to authenticate the crafts sold in its shop. This tag dates from 1949. *Qualla Arts and Crafts Mutual, Inc.*

to add arts and crafts to the curriculum. "Arts and crafts didn't mean anything to me," she admitted, and she was forced to learn "from the ground up." Still, Flanagan supervised the arts and crafts program for almost twenty years, when she was hired by the Indian Arts and Crafts Board as its southeastern representative. Working closely with Flanagan was Ethel Garnett, the weaving teacher whom Flanagan referred to as "a real Berea person." Garnett was considered to be on a "crusade" to "revive" weaving among the Cherokee in spite of its lack of traditional authority. A third person who worked closely with Flanagan and Garnett was Mabel Morrow, an artist introduced to the community by d'Harnoncourt. Morrow made periodic trips to the Qualla Boundary and to the Cherokee's Snowbird community near Robbinsville. She began attending Jennings's meetings in 1945 and was quick to express her opinion. "The worst thing," she said, was the "mixing of foreign made articles with the Indian made." Indeed, this was a concern shared by the national Indian Arts and Crafts Board, which paid the teachers' salaries. While Morrow's motivation appeared to be aesthetic, Jennings's was always economic. "Unless a constructive program for the Indians is developed with assistance, the white people will make all the money from the tourist business."[77]

Cherokee Indian Agency superintendent Joe Jennings (left) with Principal Chief Jarrett Blythe (right). *North Carolina State Archives, Travel and Tourism Division Photographic Files.*

AN ARTS AND CRAFTS COOPERATIVE

In the fall of 1945, Superintendent Jennings convened a meeting to which he invited a number of craft makers. Prior to this meeting, the only Cherokee craftsmen that had participated in the ongoing conversations were G.B. Chiltoskey and Lottie Stamper, no doubt because they both taught in Flanagan's program. This expanded meeting was attended by several basket weavers, including Lizzie Youngbird, Caroline Wolfe and Lucy George, as well as woodcarver Watty Chiltoskie, Goingback's brother.

Besides Misses Morrow and Flanagan, other school representatives came, including Principal Sam Gilliam and metal teacher Teofil Sniegocki. Jennings initiated discussions specifically aimed at forming an "Arts and Crafts Association"; as always, his reasoning was economic. Under such an umbrella, he proposed that makers could get more for their work, and a retail venue could give them a "place for ready sale." The group discussed holding "buying days" for work (a practice that was adopted and still in use today). Before the end of the year, a committee of craft workers was elected to represent various communities and disciplines. Maude Welch represented pottery. By spring, the group had drafted articles of incorporation that were circulated for comment. Although Jennings hoped to have the organization up and running by April 1, there were several items that needed approval from his superiors. Still, the group wanted to move quickly in order to organize for the upcoming summer season and planned to use the sales room in the council house as a way to begin, but when the group set up an executive committee with representatives for each discipline, curiously, pottery was not included.[78] Was that because there were few potters participating? Looking at comments from shop owners and potters themselves, it seems that, by the 1940s, pottery on the Qualla Boundary was doing just fine.

It is difficult to know what the true thoughts were of Cherokee craftsmen during these organizational meetings, since their recorded responses were mediated by Jennings and his secretary, Alice Seaver, who wrote up a summary of each meeting. When Jennings asked them "to express their opinion of the association," Seaver recorded, "The general consensus of opinion was that the association would be a very good thing." But apparently not everyone agreed, as some were opposed in principle. Jennings had modeled the arts and crafts association after popular agricultural cooperatives, which had emerged as a voice for farmers in the 1920s. Co-ops provided practical services to members like the distribution of seed and fertilizers. Such mutual organizations were formed to serve their constituents, and Jennings suggested some of these same practicalities could apply to Eastern Band craftsmen. One suggestion that came up repeatedly was to provide raw materials to artisans through cooperative purchase. In spite of its popularity with some, Flanagan recalled that the idea faced the "worst opposition you ever heard" from those who viewed these collective support organizations as communistic. With an obvious aim to remedy the situation, Jennings brought in someone to talk specifically about cooperatives and how they functioned.

McKinley "Mack" Ross, founding president of Qualla Arts and Crafts, hands over a check to charter member Cora Wahnetah. *Qualla Arts and Crafts Mutual, Inc.*

Winning over the support of a number of Cherokee craftsmen, Jennings proposed a constitution and bylaws to the Department of the Interior. He received approval in midsummer, and in August, the group elected McKinley "Mack" Ross (1899–1990) as its first president.[79]

For a few years, the new association operated out of a one-room sales shop that had been assigned to them at the agency. To handle sales, they hired Roxana Stamper, the *Road to Soco* weaver. In 1949, the arts and crafts cooperative rented a storefront on Highway 441 on the grounds of the Boundary Tree, a major resort in town. In 1954, the group took its current name, Qualla Arts and Crafts Mutual, Inc., and was formally incorporated under North Carolina state law. In the late 1950s, Cecelia Taylor, Roxana Stamper's sister, was hired as store manager and Virginia Standingdeer as bookkeeper. The new organization provided advantages to Cherokee's craft workers. It paid upfront for work delivered, provided opportunities to sell work year round and paid dividends to members at the end of each year. Qualla Arts and Crafts remained at the Boundary

QUALLA ARTS AND CRAFTS COOPERATIVE
INVITES YOU TO THE OPENING OF
CRAFT SHOP
THURSDAY APRIL 7. 1949
2:00 PM 5:00 P.M.

BOUNDARY TREE DEVELOPMENT CHEROKEE. N.C.

Qualla Arts and Crafts Cooperative moved into a sales shop at the Boundary Tree, a development complex created to enhance tourism on the Qualla Boundary. *Qualla Arts and Crafts Mutual, Inc.*

Betty DuPree was manager of Qualla Arts and Crafts from 1972 until her retirement in 1997. *Southern Highland Craft Guild Archive.*

A 1976 rendering of Qualla Arts and Crafts Mutual's rennovated stone-sided building. *Qualla Arts and Crafts Mutual, Inc.*

Tree location for ten years, until 1960, when it moved to its present location. Gertrude Flanagan recalled the move as exciting and hectic. When the Boundary Tree shop was closed on Saturday night, Flanagan and Mollie Blankenship brought in a team of co-op members and teenage boys to transport everything to the new location. The new shop opened early the next morning. In 1976, the building was renovated to its present state using "native stone and discreetly stained wood." Its "large display windows" showed off the display of arts and crafts for sale. When sold, items were tagged with a certificate of authenticity.[80]

ᏔᎢᏫᏚ ᎢᏪᎤᎠᏪᎢ ᏚᏞᏐᏚ

Soneladu Iyasgohisgwa Gadaguga
19 hundreds pottery

POTTERY IN THE TWENTIETH CENTURY

I am a Cherokee potter.
With my hands I create.
With my mind I create.
With soft clay I create...
The art of pottery had never left my mind.
What I learned as a child I never forgot.
—Louise Bigmeat Maney[81]

Among the fifty-nine charter members joining the new artisan cooperative were noted potters Rebecca Youngbird, Maude Welch and Cora Wahnetah. Of the three, only Wahnetah truly belonged to the twentieth century. Every one of the earlier potters—including Susannah Owl, Nettie Owl, Lillie Bryson, Charlotte Bigmeat, Rebecca Youngbird and Maude Welch—was born in the nineteenth century. Theirs was a generation heavily influenced by Catawba pottery. When the Qualla Arts and Crafts cooperative was established, two of the older generation—Rebecca Youngbird and Maude Welch—immediately joined. While the cooperative certainly supported authentic tradition and fine craftsmanship, its primary reason for coming into existence was economic. During the decades that followed, its exhibitions and press championed heritage methods and traditional forms. The generation of twentieth century potters—Bigmeats, Cora Wahnetah, Edith Bradley and Amanda Swimmer—each attempted, in her own way, to reintroduce "old ways" into a new market of pottery for the public.

CHARLOTTE BIGMEAT

Charlotte Welch Bigmeat (1887–1959) was steeped in the pottery tradition. Through marriage, she was related to Maude Welch (Maude married Charlotte's brother, Will). Her youngest daughter claimed their family history included turn-of-the-century potter Iwi Katalsta (Eve Catolster). When Charlotte married Robert Bigmeat, she forever made the Bigmeat name synonymous with high-quality Cherokee pottery. Writing about the Bigmeat family always includes speculation on their name. Its derivation has been proposed to mean "big meeting place" and alternately an indication that the family raised beef, which would have been a distinctive profession among a people whose traditions depended on hunting and fishing. Charlotte Bigmeat influenced Cherokee's pottery tradition through the skills of her potter-daughters: Tiney, Ethel, Elizabeth, Mabel and Louise. She raised five daughters and a son on Wrights Creek in the Painttown section of the Qualla Boundary. Sisters-in-law Charlotte Bigmeat and Maude Welch attended the earliest discussions about forming an artisan association in Cherokee. As the project moved forward, they were joined by the younger generation, sisters Elizabeth and Tiney, Charlotte's daughters.

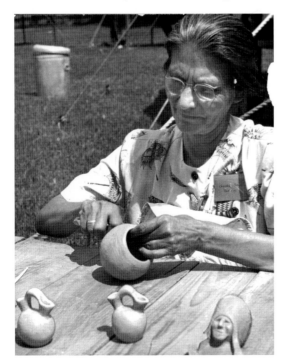

Charlotte Bigmeat is shown demonstrating at the 1948 Craftsman's Fair of the Southern Highlands in Gatlinburg, Tennessee. She is wearing a nametag that reads, "Cherokee School Pottery." *Southern Highland Craft Guild Archive.*

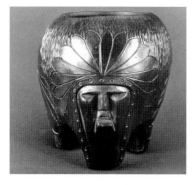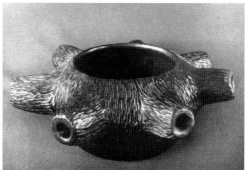

Bigmeat family pottery. *Qualla Arts and Crafts Mutual, Inc.*

Charlotte Bigmeat and Maude Welch must have formed an impressive duo dominating the pottery market in Cherokee. As they grew older, Charlotte Bigmeat's daughters would step into their place. Over the years, the family created pottery that became a signature style and Bigmeat standard. An Indian head pot was one form that was made by the elder Bigmeat and later reproduced by her daughters. This small bowl appealed to the growing tourist trade; its "Indian" motif a memento of a visit to Cherokee. The bowl was polished to a high sheen to create a smooth surface for the design applied to its side. The stylized feathered headdress was drawn onto the body of the pot by incising. Another pottery form often produced by the Bigmeat family was the seven-sided peace pipe. This piece was finished with a surface treatment known as a bark design for its resemblance to tree bark. The pipe's seven arms represent the seven Cherokee clans. The pot does have some precedent in archaeology, but its protrusions are exaggerated from the original. The words of Charlotte Bigmeat's youngest daughter sum up the family's approach: "In its final form, perfection, quality, and tradition are our standards."[82]

BIGMEAT FAMILY

All of Charlotte Bigmeat's daughters made pottery at one time or another. The Bigmeat potter-daughters acknowledged that it was an "activity of hard work." Tiney Bigmeat Thompson (1913–1999) was the oldest of Charlotte Bigmeat's daughters. In a 1940s-era photograph, Tiney is seen processing clay through a meat grinder. Her younger sister, Lizzie (Elizabeth Bigmeat

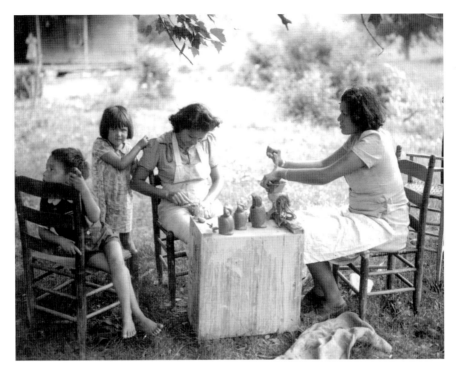

Elizabeth (left) and Tiney Bigmeat (right), circa 1940. *Great Smoky Mountains National Park.*

Jackson), is carving on a piece of pottery. They have a number of finished pots to show for their afternoon's work. Like many Cherokee craftsmen, the Bigmeats worked outdoors. One of their sisters recalled that they usually worked under a large maple tree in the yard. Later, when their mother wanted a shop, their father built one for her. From town, a guide would take tourists to various artisans' homes, where they would be able to purchase crafts directly and, perhaps, watch them being made.[83]

Ethel Bigmeat Queen (1916–1942) was the next daughter born into the Bigmeat family. She was pictured on a postcard posed with a selection of Cherokee crafts. The clay owls displayed on her blanket are similar to those shown in the picture of her sisters, Tiney and Elizabeth working in their yard. These forms, too, have a precedent, although the owls made by the Bigmeats were more stylized than prehistoric owl effigies. Other pieces visible in the photograph are a seven-sided peace pipe and several pots with an Indian head motif. Cherokee potter Joel Queen continues the legacy of Ethel Bigmeat, his paternal grandmother. He recalled that his grandmother

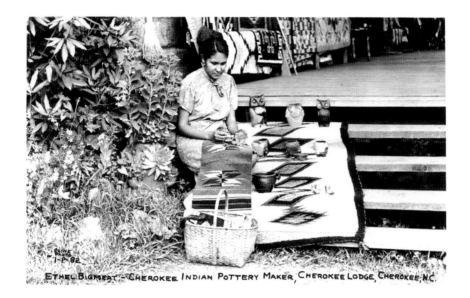

Postcard of Ethel Bigmeat. *North Carolina Collection, University of North Carolina Library at Chapel Hill.*

gathered clay from the riverbank on Macedonia Road, shoveling it out of a huge pit and carrying it four miles back to her house in metal pails. He attempts to follow her tradition, collecting clay once a year, drying it in ten-pound cakes in preparation for a year of making his own pottery.[84]

Elizabeth "Lizzie" Bigmeat Jackson (1919–2008) and her sister, Mabel Bigmeat Swimmer, both moved away from North Carolina as adults. Elizabeth married and moved to Flint, Michigan, where she continued to make pottery. Several times a year, she packed her car with pottery and brought it back to fire and sell at local craft shops. A 1979 photograph, most likely made by the Indian Arts and Crafts Board, shows a coiled and modeled blackware water pipe that she made. The base of the pipe is incised with a friendship pattern; along its sides are two modeled lizards. Another form made by Lizzie Jackson was an oil lamp with a shallow stable bowl used to hold oil. The handle of this particular oil lamp has been shaped into the form of a bird. A pot with a totemic figure, such as this one, is also called an effigy pot. To make this piece, earthenware clay was shaped using the coil method and then burnished, before carving and incising the details of the bird's head into the clay. Jackson expressed a sentiment that is common among artisans who grew up in a craft producing family. "When

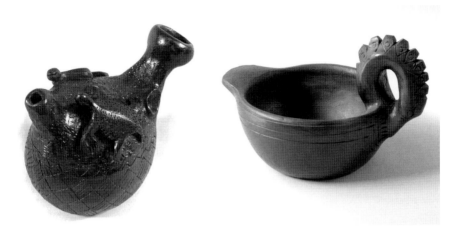

Pipe and effigy oil lamp by Elizabeth Bigmeat Jackson. *Qualla Arts and Crafts Mutual, Inc.*

I started making pottery," she said, "it was because I enjoyed the work, and we needed the extra income." Later, as her work matured and she realized the value of her creative gift, she remarked, "Today, the money is not as important as the pleasure that I get from my work."[85]

Sister Mabel Bigmeat Swimmer (1925–1991) made pottery as part of growing up in the Bigmeat family. "My mother taught her daughters how to make Cherokee pottery, which helped provide the family with extra income that was needed then, as it is today with my family," she recalled. For a time, she worked at the Oconaluftee Indian Village where she demonstrated for visitors. Later, she left to join her older sister in Flint, Michigan. There, she continued to make pottery, bringing it home by the carload. She expressed her interest in pottery making within the context of a sustainable culture. "I enjoy doing this work," she said, "and hope that it will continue to be a part of our Cherokee culture in the years ahead." In 1979, Qualla Arts and Crafts Mutual hosted an exhibition of the work of three of the Bigmeat sisters: Elizabeth Bigmeat Jackson, Mabel Bigmeat Swimmer and Louise Bigmeat Maney. The exhibition noted that the "Bigmeat sisters each has developed her own individual methods of firing, coloring, and applying surface designs."[86]

The youngest of Charlotte Bigmeat's daughters, Louise Bigmeat Maney (1932–2001) was, certainly, the most experimental. Louise started out like her sisters, learning pottery from their mother. As the youngest, she began working in clay when she was just six or seven years old. When she was eight,

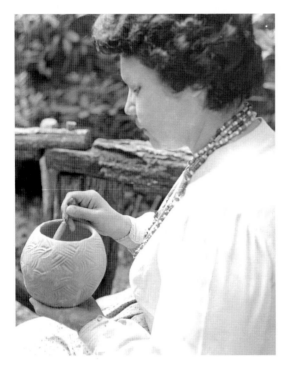

Left: Mabel Bigmeat Swimmer demonstrated pottery making at the Oconaluftee Indian Village. *Museum of the Cherokee Indian.*

Below: A highly burnished blackware vase by Mabel Bigmeat Swimmer. The vessel is impressed with the imprint of a bear's paw around the shoulder. *Qualla Arts and Crafts Mutual, Inc.*

she told her mother that she was "never going to make pottery because we had to work so hard at it." What sounded like a child's complaint actually came to pass as Louise struggled with her cultural identity. "It seemed like anything Indian was not okay," she said, explaining her experience in school. Still, she continued to assist with the pottery until her mother died, when Louise abandoned pottery altogether.

> *The period following my mother's death was a non-active time as far as my artwork was concerned. Child rearing, education and helping to provide for a family of seven children took precedence over art and much of my time and energy.*[87]

By this time, Louise Bigmeat had married John Henry Maney (born 1931). Also from Painttown, Maney was descended from a family of well-known basket weavers that included Nancy and Rowena Bradley. After all of the couple's seven children were enrolled in school, Louise went back to school as well. She finished high school and went on to take college courses during summer. She expanded her skills and education by taking courses at Haywood Community College, Western Carolina University and the Institute of

American Indian Arts. She focused on art and art education, learned how to throw on the potter's wheel and mastered the science of mixing glazes. This experience, no doubt, broadened her repertoire of forms and introduced her to other potters. For more than twenty years, Louise Bigmeat Maney worked as an educator; still, she continued to struggle with cultural conflict. Finding the school curriculum lacking, she brought in clay and taught the children how to make beads. It was a shame that she could not thoroughly enjoy her contribution; instead, she felt she was "doing something against the rules." In the late 1950s, Louise Bigmeat Maney returned to her roots as a potter, acknowledging the influence of her mother.

> *All I know I learned from her, more than I learned in school…We learned to read and write at school, but I learned all my culture from her when I was small…I am now doing what I really want to do and had wanted to do all along, but turned my back on when I was younger. Pottery is my main source of life now. I enjoy what I'm dong. I have put myself into being a potter… And what I can do best is pottery. I learned it when I was a small child. That was my gift…Creating pottery is a part of me.*[88]

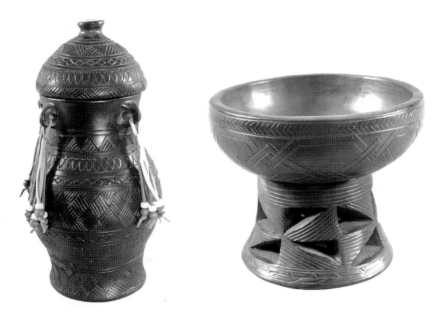

Above, left: Burial urn embellished with beads by Louise Bigmeat Maney. *Qualla Arts and Crafts Mutual, Inc.*

Above, right: Footed vessel with deep carving by Louise Bigmeat Maney. *Qualla Arts and Crafts Mutual, Inc.*

Left: Louise Bigmeat Maney is firing pottery in a wood stove. John Henry Maney often fired their work in a metal drum. *North Carolina Folklife Institute and North Carolina Arts Council; photograph by Julie Stovall Lauver.*

Below, left: Although Louise Bigmeat Maney was not opposed to using a potter's wheel, in this photograph, she is making a traditional coil pot. *North Carolina Folklife Institute and North Carolina Arts Council; photograph by Julie Stovall Lauver.*

Below, right: Maney dried her pottery in her kitchen stove. *North Carolina Folklife Institute and North Carolina Arts Council; photograph by Julie Stovall Lauver.*

When she returned to making pottery, her husband, John Henry Maney, joined her; together, they introduced modern production methods into their practice and established the Bigmeat House of Pottery at the entrance to Painttown. "My husband, John Henry got interested in helping me…Making pottery completely by hand took too much time, so we bought a wheel. Now John Henry does all the pottery-turning and the firing. I do the decorating and shaping." One characteristic of Bigmeat Pottery is its distinctive black color, the result of smoking the clay.

Documentary of Six Cherokee Artists brochure featured Louise Bigmeat and John Henry Maney (bottom center), 1976. *Qualla Arts and Crafts Mutual, Inc.*

In spite of the high level of breakage, the Maneys fired their pottery in a large drum. Maney explained their process: "John Henry does the firing in a large drum. If the drum is sealed, the pottery gets a smoky or black color. Leaving the can open completely like the ancient Indians did makes the pottery come out with a combination of black and the natural color of the clay." In 1976, she and John Henry were part of a *Documentary of Six Cherokee Artists*, an exhibition organized to inaugurate the opening of a new members gallery at Qualla Arts and Crafts Mutual. The exhibition brochure named them "two of the most competent potters in the Cherokee Indian Tribe." Besides their use of the wheel, the artist team was innovative and experimental. Louise worked out designs for their pottery on paper and then transferred these designs onto the pottery surface. Both Maneys did some throwing, but they returned to their Cherokee roots when it came to "designing, carving, polishing, and firing," or so Louise claimed. In reality, the Maneys continued to experiment with pottery forms, creating unique objects, like a pedestal bowl with deep carvings and a burial urn with added dangles of beads. In addition to their retail operation, the couple set up an extensive display of historical photographs and artifacts, preserving and honoring their ancestral tradition bearers.[89]

Louise Bigmeat Maney was active in the western North Carolina crafts community. She participated as a demonstrator for the Southern Highland

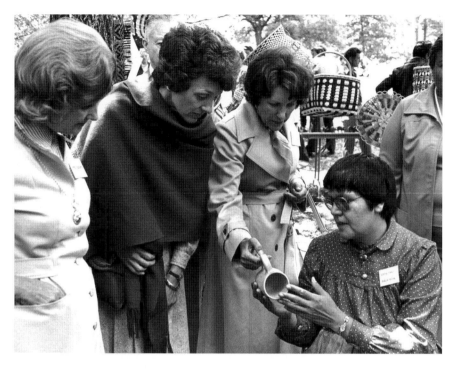

Louise Bigmeat Maney shows off her work to Joan Mondale, wife of Vice President Mondale at the 1977 groundbreaking of the Folk Art Center on the Blue Ridge Parkway. *Southern Highland Craft Guild Archive; photograph attributed to David Gaynes.*

Handicraft Guild and, in 1977, was part of a delegation of Cherokee artisans who commemorated the groundbreaking of the Folk Art Center on the Blue Ridge Parkway near Asheville. Attending the ceremony was Joan Mondale, wife of Vice President Mondale. In 1998, Maney received a North Carolina Folk Heritage Award. She passed away in 2001 and was given the rare honor of being named a "Beloved Woman" posthumously by the Eastern Band.

CORA WAHNETAH

Cora Arch Wahnetah (1907–1986) learned the techniques of both coiled and modeled pottery from her mother, Ella Long Arch (1889–1978), a potter who had shared the pretourist market with the Harris-Owls. Unlike Susannah and Nettie Owl, Ella Arch was still actively making pottery in the 1930s. Stites called her "an independent, a rugged individualist,"

although his comments may be a veiled reference to her opposition to his intrusive methods. Arch and the younger generation of women were featured on a series of postcards promoting Cherokee crafts. In one, Ella Arch is posed with her daughter-in-law, Sarah, who is burnishing a pot in her lap, and Cora, who is stringing a bead loom. Ella Long was just sixteen when she married Johnson Arch. Coincidentally, he was the grandson of Jennie Arch, the "aged" artisan named by Harrington when he came to the Qualla Boundary in search of potters. Cora Wahnetah was born into one pottery family and married into another. She married Samuel Wahnetah, the grandson of Catawba potter Susannah Owl. Certainly, Wahnetah did not have such strong ties to the Catawba tradition as her mother's generation, but she did grow up within that same small circle of native potters. Although she was quite aware of more modern methods, she consciously worked within the parameters of tradition. She remembered her family's all-day trips to dig clay on Soco Creek, traveling by horse and wagon. In spite of the long day of hard work, she recalled that she spent "many happy hours" collecting clay for

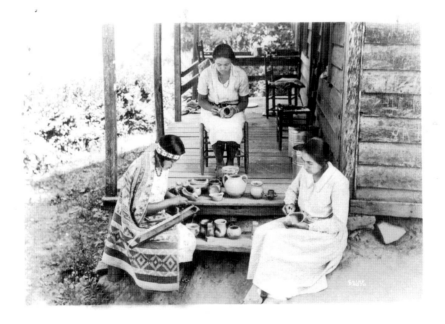

While the postcard is labeled "Making Cherokee Pottery," the woman at left is working on a bead loom. The three artisans are believed to be Cora Arch (Wahnetah); her sister-in-law, Sarah Arch and her mother, Ella Arch. *Hunter Library Special Collections, Western Carolina University.*

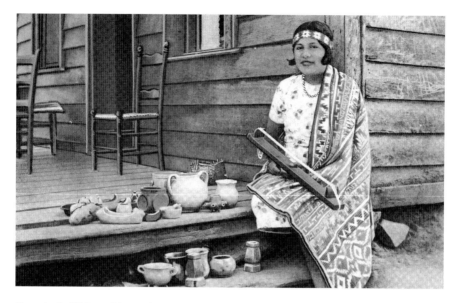

Cora Arch (Wahnetah) posed as a "Cherokee princess" with loom and pottery. *Hunter Library Special Collections, Western Carolina University.*

her family's work. "I have never made any pottery on the wheel because I do not like to make any two pieces alike," she said. Citations for her work often included statements referring to her preference for simplicity. A 1971 exhibition brochure described her process as using "simple wooden hand tools" and pit-firing methods.[90]

By the time Cora Wahnetah became a potter in her own right, she decided to learn about older pottery traditions. She had the benefit of working closely with Madeline Kneberg (Lewis), an anthropologist from the University of Tennessee in Knoxville. Kneberg was hired by the Cherokee Historical Association to draft an interpretive plan for a proposed reconstructed village that would serve as a living history museum for the tribe. Once opened, the Oconaluftee Indian Village featured Cherokee people at work in costumes, circa 1750. In an interview, Wahnetah said that Kneberg "taught me just all I know about the ancient method" of making pottery. But it appears that the relationship was more a collaboration than Wahnetah's modest statement reveals, since Kneberg cites Wahnetah's methods in her report. While most of the pottery section in Kneberg's 1954 plan references Mooney and Harrington, it was Wahnetah who assisted the anthropologist in developing the mechanics of making pottery at the village.[91] After the village opened, Wahnetah worked there as a demonstrator.

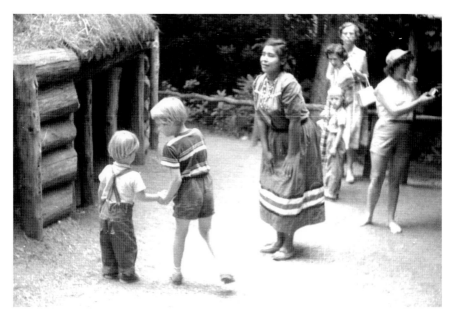

Oconaluftee Indian Village brought families to learn about 1750s Cherokee life from costumed interpreters. The reconstructed village remains an entertaining and educational tourist site today. *Museum of the Cherokee Indian.*

Wahnetah followed the "ancient method" of firing her pottery as she did with forming it. She pit fired her hand-formed pieces using wood, which gave her work a "distinctive dark and evanescent wood-smoked finish." This method was not what she learned from her mother, who fired work in the oven of a wood cookstove. Wahnetah was exacting with her process. "I have to pick a certain type of day to burn pottery. On damp days I don't do my burning. It has to be a real sunshiny, clear day. The pottery that's burned on a dark day—rainy days or damp days—doesn't turn out as well as if it was fired on warm sunshiny days."[92]

In a 1971 brochure about her work, Cora Wahnetah was described as "one of the most ingenious contemporary Indian potters of the eastern United States." In the exhibit brochure, she spoke eloquently about her pottery. She was inspired, not by the work's economic value, but by the process itself.

> *I make pottery not for the money there is in it but because I love to get my hands in the clay, forming it into any shape I have in mind. I have never made any pottery on the wheel because I do not like to make any two pieces*

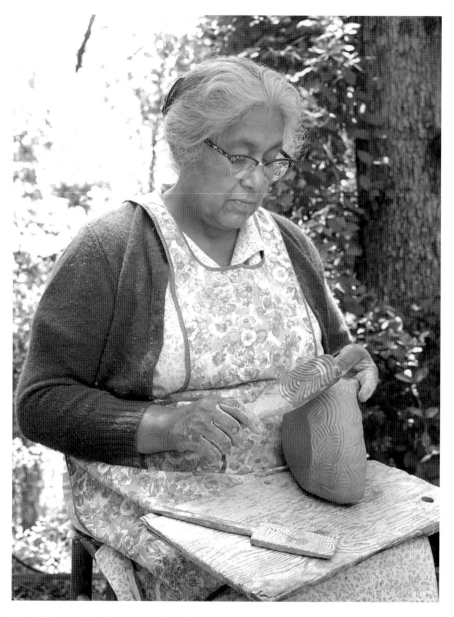

Cora Wahnetah is using a carved paddle to produce a curvilinear pattern. *Qualla Arts and Crafts Mutual, Inc.; Indian Arts and Crafts Board photograph.*

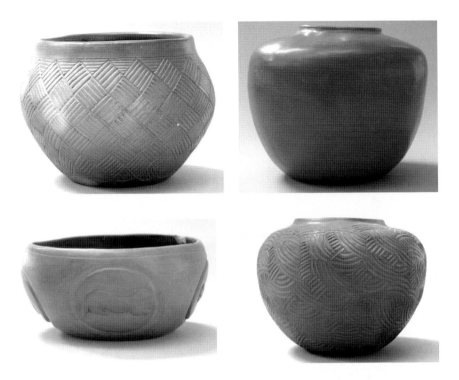

Clockwise from top left: Vessel with incised surface made by Cora Wahnetah; Vessel with highly burnished surface made by Cora Wahnetah. This pot was left undecorated and, instead, was finished by burnishing to yield a smooth surface; Vessel with paddle-stamped surface made by Cora Wahnetah; Vessel made by Cora Wahnetah included modeled appliqué animal shapes around its circumference. *Qualla Arts and Crafts Mutual, Inc.*

alike. After I watch the vase or pot dry enough to get carving on it, I enjoy the quietness as I work out a vessel and get it ready for the burning. When the fire has burned out, there is pleasure when I find the vessel has burned well, with just the color I like. It is then that I give thanks for my work.

The exhibition, sponsored by the Indian Arts and Crafts Board, Qualla Arts and Crafts and North Carolina Arts Council, included seventeen "richly-textured decorative" forms. These included effigy bowls, jars, a four-stemmed peace pipe and a wedding vase.[93] While Wahnetah constructed her pottery according to tradition, she was able to produce a wide variety of surfaces, having mastered multiple techniques, including paddling, incising, burnishing and modeling.

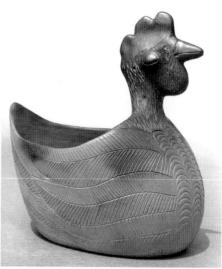
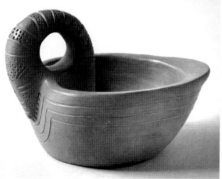
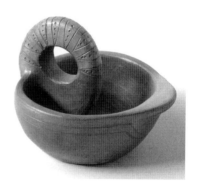

More than any other potter of her generation, Wahnetah seemed intent to produce a broad spectrum of pottery forms.

Clockwise from top left: Bird form, modeled and incised made by Cora Wahnetah; Hen form, modeled and incised by Cora Wahnetah; Oil lamp effigy vessels made by Cora Wahnetah. Wahnetah was known for her "strikingly modeled" effigy bowls that were "first produced for ceremonial use by her ancestors centuries ago." *Qualla Arts and Crafts Mutual, Inc.*

Cora Wahnetah was an avid supporter of Qualla Arts and Crafts Mutual cooperative. Her name does not appear on any of the early meetings rosters, but she was the only one of the twentieth-century potters profiled here who was a charter member of the guild. Before the formation of the co-op, Wahnetah carried her work to Bryson City and Chimney Rock. Once the cooperative was up and running, she sold almost all of her pottery through this one outlet. She particularly noted the importance of the exhibition series. Besides the exposure, which she acknowledged was important, she thought that seeing the finest crafts helped other craftsmen improve their work. In an interview, she remarked, "Qualla has meant everything to me… Most of the members would say the same thing. It has helped them a lot."[94]

EDITH WELCH BRADLEY

Edith Welch Bradley (1918–1999) learned pottery from her mother, Maude Welch. "We made our living from mother's pottery," she recalled. Growing up in Birdtown, she accompanied her parents when they moved around to find work and remembered their stay in South Carolina. She

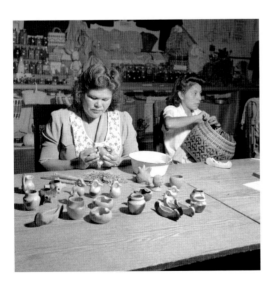 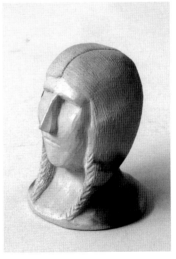

Above, left: Edith Welch Bradley was photographed demonstrating at the Cherokee Indian Fair. The basket weaver may be Rowena Bradley. *North Carolina Archives; North Carolina Department of Tourism; photograph by John H. Hemmer.*

Above, right: Modeled head by Edith Welch Bradley. *Qualla Arts and Crafts Mutual, Inc.*

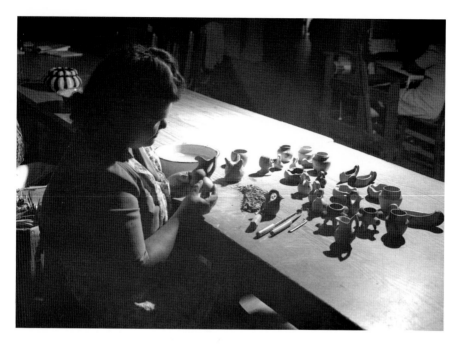

Edith Welch Bradley making souvenir pottery, including miniature wedding vases, Rebecca pitchers, peace pipes and canoes. Although not a common form, there is a carved head in the middle of the table. *North Carolina Archives; North Carolina Department of Tourism; photograph by John H. Hemmer.*

also recalled the financially difficult times, saying that her mother received little for a finished pot. Still, even as the demand for her work grew, Maude Welch was reluctant to raise her prices. So much of her business was a family enterprise. Charlotte Bigmeat was Edith Welch's aunt, and all five of Charlotte Bigmeat's daughters were her cousins, so Edith was surrounded by potters and the pottery process. Her aunt was pottery teacher Bettie Welch Smith. While she was not directly related to the Harris-Owls, they were close friends of her mother's, and Maude Welch sold her pottery through them. Like many extended pottery families, family members assisted with some of the work. Her father helped by scraping the pottery smooth and the children helped with finishing. "Many a night we sat up working pots…I rubbed pots for her. I'd rub and rub and rub." With young, inexperienced hands, there was always a danger of breakage. "We got whipped if we bothered Mama's pots," she recalled. As a child, Edith Welch was already familiar with the process of making pottery, including ways of displaying and selling. In a friendly competition, she competed against her mother at the Cherokee Indian

Fair, making miniature versions of each of her mother's entries. "It was the only time she got beat," Edith remarked proudly. Her winning work was snapped up by the owner of a pottery shop.[95]

AMANDA SWIMMER

Amanda Sequoyah was the youngest child born to Molly Davis Sequoyah and Running Wolf Sequoyah. The family lived in a log house in the Straight Fork community of Big Cove, a remote section of the Qualla Boundary. Although Big Cove is known for its craft traditions, Sequoyah family activities were centered on farming and providing for a dozen children. The family raised all of its own food, including corn, cane and some tobacco. From Big Cove, there was no transportation down to the school in Yellowhill, so many children did not go beyond the elementary grades offered at the local day school. Married to Luke Swimmer and raising nine children of her own, day-to-day life was a physical challenge. Amanda Swimmer recalled:

> *Me and my husband had to leave* [Big Cove] *by 8 o'clock to go to Cherokee to get some groceries. This road wasn't nothing but a railroad track, and the train did not run on this track. We just walked...* [and] *we'd get to Cherokee by 11 o'clock in the morning.* [On the way back] *we had to get a taxi; just one taxi was running down Cherokee. He had to bring us there through the ford...cross the river, and go across that mountain there* [as far as he could go]...*we had to carry our groceries up here to the house—about a mile and a half, two miles.*[96]

Amanda Sequoyah Swimmer (born 1921) learned a lot of what she knows through trial and error. She did not have the benefit of being raised in an extended pottery family. She recalled her first experiments with clay:

> *After I got married, I decided to hunt that clay right above where I lived. I made some small bowls and I told my husband, I said, "Let me try to burn them. Just make a hole right there in the yard." We just piled wood in there and burned my pottery. And that came out pretty good. And I just kept on playing with that wood, off and on.*

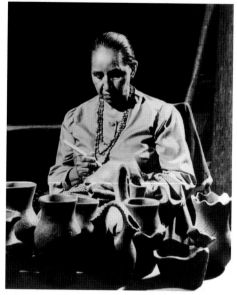

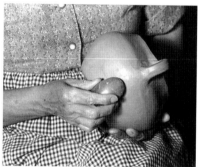

Above, left: Amanda Swimmer and an array of her pottery made for the public at the Oconaluftee Indian Village. *Qualla Arts and Crafts Mutual, Inc.*

Above, right: With her polishing stone, Amanda Swimmer is burnishing a piece of pottery. *Qualla Arts and Crafts Mutual, Inc.*

Swimmer explained how she used different woods to achieve a variety of colors on her pots. "I use poplar, dried poplar mostly, and maple. Then if I want to make a light color, I just use hardwood. That's oak and locust. If you use locust, it give you an orange color. Hardwood uses more flame and less smoke, and the soft wood makes more smoke than flame." Her understanding of the mechanics of firing helped her achieve a goal that was sought after in the 1930s, to make pottery waterproof. She went on to explain, "You can't cook in them, but they can hold water."[97]

Swimmer began to work at the Oconaluftee Indian Village. That first summer, she demonstrated finger weaving but soon moved to pottery. She learned mostly by observation, having "sat with the women that knew how to make pottery. I just learned more from that." At the village, she became acquainted with the best of Cherokee's potters, including Cora Wahnetah, who had helped establish the interpretive methods at the village. Swimmer worked as a demonstrator for approximately thirty-five years. Her son married Mabel Bigmeat, another village demonstrator.[98]

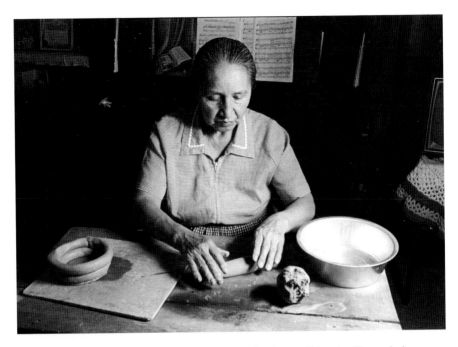

Amanda Swimmer makes her unique pottery vessels using traditional coiling techniques. *Qualla Arts and Crafts Mutual, Inc.*

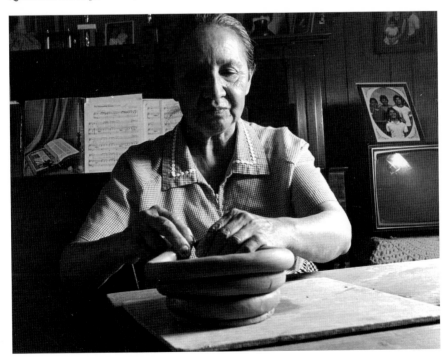

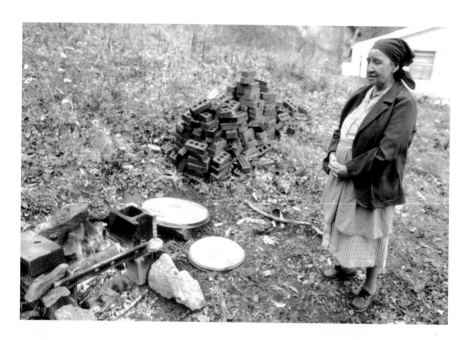

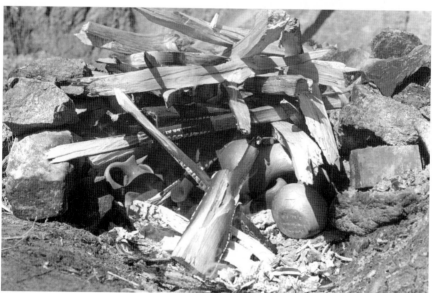

Amanda Swimmer preferred firing her pottery outdoors. *Qualla Arts and Crafts Mutual, Inc., and North Carolina Folklife Institute and North Carolina Arts Council; photograph by Cedric N. Chatterley.*

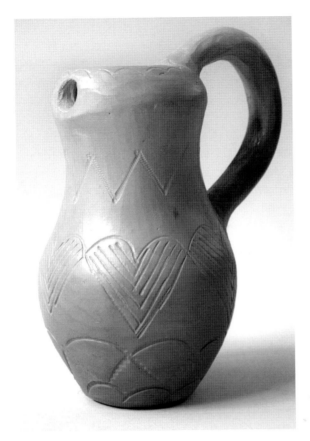

Earthenware pitcher with incising by Amanda Swimmer. *Qualla Arts and Crafts Mutual, Inc.*

Swimmer received accolades from a variety of sources. Qualla Arts and Crafts Mutual honored her with an exhibition of her work in the early 1980s. In 1994, she received the state's highest honor, naming her a recipient of a North Carolina Heritage Award. In 2005, she was awarded an honorary doctorate from the University of North Carolina–Asheville. What is most remarkable about Swimmer is that, even at age eighty-one, she expressed enthusiasm for her craft. She enjoys working with young children, teaching them to work with clay. She is careful to fire their pottery so that none of their pieces break. "Whenever they get kids that want to make pottery, they call me…They really want to learn. They can make some things I can't make!" she exclaimed.[99]

A TWENTY-FIRST CENTURY GUILD

In the spring of 2002, a group of Cherokee artisans got together to learn more about heritage crafts. The Museum of the Cherokee Indian and the Research Laboratories of Archaeology at University of North Carolina–Chapel Hill hosted a series of workshops that allowed potters to examine archaeological specimens in their collection. As a result of their work and interest, the group formed the Cherokee Potters Guild. Founding members of the new guild included Davy Arch, Bernadine George, Betty Maney, Melissa Maney (Cora Wahnetah's granddaughter), Shirley Oswalt, Joel Queen (Ethel Bigmeat's grandson), Dean Reed, Alyne Stamper, Mary Ann Thompson and the elder, Amanda Swimmer. A brochure produced by the guild proclaimed, "Now, Cherokee potters have reclaimed their heritage and, once again, are making stamped, hand-built, thin-walled waterproof pots." Writing about the new guild, archaeologist Brett Riggs noted that these ceramists are

> *expanding their current repertoires to encompass an artistic and technological lineage that they can claim as exclusively Cherokee. Like their grandmothers and great grandmothers at the turn of the last century, contemporary Cherokee potters must articulate with an external commercial market, but now on artistic terms that the potters themselves define.*[100]

NOTES

TRADITIONS OF THE EARTH

1. For brief introductions to pottery making around the world, see introductory chapters in Prudence M. Rice, *Pottery Analysis: A Sourcebook* (Chicago: University of Chicago Press, 1987) or Carla M. Sinopoli, *Approaches to Archaeological Ceramics* (New York: Plenum Press, 1991). Although there is an association between settling down and producing pottery, not all settled peoples native to North America made pottery. For example, the peoples of the Northwest Coast did not have indigenous pottery traditions.
2. James Mooney, *Myths of the Cherokee* (Washington DC: Government Printing Office, 1897–1898; repr., New York: Johnson Reprint Company, 1970), 163.
3. For a discussion of Cherokee lands, past and present, see Barbara R. Duncan and Brett H. Riggs, *Cherokee Heritage Trails Guidebook* (Chapel Hill: University of North Carolina Press, 2003).
4. See H. Trawick Ward and R.P. Stephen Davis Jr., *Time Before History* (Chapel Hill: University of North Carolina Press, 1999) and Jefferson Chapman, *Tellico Archaeology: 12,000 Years of Native American History* (Knoxville: University of Tennessee Press, 1995) for discussions of the archaeological interpretation of the Cherokee heartland written for nonarchaeologists.

5. Christopher B. Rodning, "Reconstructing the Coalescence of Cherokee Communities in Southern Appalachia," in *The Transformation of the Southeastern Indians, 1540–1760*, ed. Robbie Ethridge and Charles Hudson (Oxford: University of Mississippi Press, 2008), 208–36.

6. Ward and Davis, *Time Before History*, 142–43.

7. Useful online summaries of the material culture history of the Appalachian Summit include http://www.rla.unc.edu/ArchaeoNC/time/wood_App.htm and http://www.crai-ky.com/education/reports-cumberland.html#Appalachian%20Summit1.

8. See Bennie C. Keel, *Cherokee Archaeology: A Study of the Appalachian Summit* (Knoxville: University of Tennessee Press, 1976) and Larry R. Kimball, Thomas R. Whyte and Gary D. Crites, "The Biltmore Mound and Hopewellian Mound Use in the Southern Appalachians" *Southeastern Archaeology* (2010), 44–58, for discussions of Connestee sites with evidence of Hopewell interaction.

9. David J. Hally, "An Overview of Lamar Culture," *Ocmulgee Archaeology 1936-1986*, ed. David J. Hally (Athens, University of Georgia Press, 1994), 144–74.

10. See Roy S. Dickens Jr., *Cherokee Prehistory: The Pisgah Phase in the Appalachian Summit Region* (Knoxville: University of Tennessee Press, 1976) and a more recent reassessment by Christopher B. Rodning, "Temporal Variation in Qualla Pottery," *North Carolina Archaeology* 57 (2008).

11. For a discussion of Overhill pottery vessels, see Duane H. King, "Vessel Morphology of Eighteenth Century Overhill Ceramics," *Journal of Cherokee Studies* 2 (1977), 154–69.

12. Rodning, "Temporal Variation."

LIVING OFF THE LAND

13. Natalie Curtis, "Our Native Craftsmen," *Southern Workman* 48 (August 1919), 389.

14. Samuel Cole Williams, ed., *Adair's History of the American Indians* (New York: Promontory Press, 1930), 238.

15. Henry Timberlake, *Memoirs: 1756–1765* (London, 1767; repr., Marietta, GA: Continental Book, 1948), 69–71; William Bartram, *Travels through North and South Carolina, Georgia, East and West Florida* (London, 1792; repr., Savannah, GA: Beehive Press, 1973), 365.

16. Museum of the American Indian, *Naked Clay: 3000 Years of Unadorned Pottery of the American Indian* (New York: Heye Foundation, 1972), 3; Williams, *Adair's History*, 456. For a full discussion on the role of women, see Theda Purdue, *Cherokee Women: Gender and Culture Change: 1700–1835* (Lincoln, University of Nebraska Press, 1998).

17. For a full history of Wedgwood's attempt to secure clay from Cherokee territory, see William L. Anderson, "Cherokee Clay, from Duché to Wedgwood: The Journal of Thomas Griffiths, 1767–1768," *North Carolina Historical Review* 63, no. 4 (1986), 477–510. *Western North Carolina Section at a Glance* (Washington, D.C.: Southern Railway, circa 1912), 40–42.

18. Freeman Owle in Barbara R. Duncan and Davy Arch, eds., *Living Stories of the Cherokee* (Chapel Hill: University of North Carolina Press, 1998), 221–22.

19. John R. Finger, *Cherokee Americans: The Eastern Band of Cherokees in the Twentieth Century* (Lincoln: University of Nebraska Press, 1991) 6.

20. "In the 'Land of the Sky,'" *New York Times*, April 7, 1895.

21. W.H. Holmes, "Aboriginal Pottery of the Eastern United States," *Twentieth Annual Report of the Bureau of American Ethnology* (Washington: Government Printing Office, 1903), 53–56.

22. Holmes, "Aboriginal Pottery," 18, 48.

23. Holmes, "Aboriginal Pottery," 53; Thomas J. Blumer, "Catawba Influences on the Modern Cherokee Tradition," *Appalachian Journal* 14, no. 2 (Winter 1987), 153–73. Blumer spells her name Sallie Wahoo and cites an 1888 letter from Mooney noting the death of Sally Screech Owl. Screech Owl is the English translation of her name, spelled phonetically as Wahuhu or Wahoo.

24. Henry M. Owl, "Catawba Indian Woman Inspires Cherokees," *Charlotte Observer*, January 12, 1930; Blumer, "Catawba Influences," 156.

25. Owl, "Catawba Indian"; Blumer, "Catawba Influences," 156.

26. *Western North Carolina*, 53–56; Blumer, "Catawba Influences," 158, 172.

27. Blumer, "Catawba Influences," 158, 162.

A SHARED TRADITION

28. Kathi Smith Littlejohn, "Me-Li and the Mud Dauber," in Duncan and Arch, *Living Stories*, 40.

29. Edna Chekelee, "The Trail of Tears Basket," in Duncan and Arch, *Living Stories*, 142; Cherokee Heritage Center, *People of One Fire* (Tahlequah, OK: Cherokee Heritage Press, 2007), 27. For a discussion on the metaphoric

values related to handcraft, see Anna Fariello, "'Reading' the Language of Objects," in M. Anna Fariello and Paula Owen, eds., *Objects and Meaning: New Perspectives on Art and Craft* (Lanham MD, Scarecrow Press, 2003).

30. Gertrude Flanagan recorded interview, National Archives and Records Administration, Southeastern Division, Atlanta, Georgia; Vladimir J. Fewkes, "Catawba Pottery-Making with Notes on Pamunkey Pottery-Making, and Coiling," *Proceedings of the American Philosophical Society* 88 (July 7 1944), 100.

31. Fariello and Owen, *Objects and Meaning*, 149.

32. Allen Eaton. *Handicrafts of the Southern Highlands* (New York: Russell Sage, 1937), 21; Southern Mountain Handicraft Guild, "Minutes of the Annual Meeting," April 1, 1932, http://craftrevival.wcu.edu. Although Eaton made overtures to the Cherokee in the early 1930s, from the guild's minutes, they were not listed as members until 1936.

33. Blumer, "Catawba Influences," 163, 172.

34. *Ruralite*, "Former Cherokee Chief Taken By Death," November, 8 1932; Fewkes, "Catawba Pottery-Making," 72; Blumer, "Catawba Influences," 168; Kaye Carver Collins and Angie Cheek, *Foxfire 12* (New York: Anchor Books, 2004), 408.

35. Thomas J. Blumer, "Rebecca Youngbird: An Independent Cherokee Potter," *Journal of Cherokee Studies* 5 (1980), 43–48; Rebecca Youngbird interview, 1979, Blumer Collection, University of South Carolina–Lancaster.

36. *Atlanta Constitution*, "American Indian Exhibition Staged This Week at Southeastern Fair," September 30, 1934; *Atlanta Constitution*, "Four Indian Villages, Seminole, Pueblo, Navajo, Cherokee Show Varied Types of Construction at Southeastern Fair," September 23, 1934; *Atlanta Constitution*, "Indians of Twelve Tribes Reveal Artistry In Varied Handicrafts Practiced at Fair," October 5, 1934.

37. Collins and Cheek, *Foxfire 12*, 409; Fewkes, "Catawba Pottery-Making," 99–100; Blumer, "Catawba Influences," 164.

38. Holmes, "Aboriginal Pottery," 53; Dinah Smoker Gloyne, "Cherokee Craftsmen," *Mountain Life and Work* 26 (1951), 16; Rebecca Youngbird interview.

39. Edith Welch Brady interview, 1979, Blumer Collection, University of South Carolina–Lancaster; Blumer, "Catawba Influences," 162.

40. Edith Welch Brady interview; Fewkes, "Catawba Pottery-Making," 100; Rodney L. Leftwich, *Arts and Crafts of the Cherokee* (Cherokee: Cherokee Publications, 1970), 81; Raymond S. Stites, "Kilns for the Cherokee,"

1935, 4. National Archives and Records Administration, Southeastern Division, Atlanta, Georgia.

41. *Smoky Mountain Indian Trail (Cherokee, N.C.)*, April 25, 1934. Leftwich, *Arts and Crafts*, 86; Gloyne, "Cherokee Craftsmen," 16.

42. Fewkes, "Catawba Pottery-Making," 81; Leftwich, *Arts and Crafts*, 81; Blumer, "Catawba Influences," 163.

GALLERY OF CHEROKEE POTTERY

43. Fariello and Owen, *Objects and Meaning*, 161–62.

A POTTERY LEGACY

44. Holmes, "Aboriginal Pottery," 18.

45. Ibid., 18, 56.

46. "Indian Boarding Schools," *Indian Country Diaries*, National Public Radio, http://www.pbs.org/indiancountry/history/boarding2.html.

47. M.R. Harrington, "The Last of the Iroquois Potters," *Museum Bulletin* 133 (1909), 222–227; Mooney, *Myths of the Cherokee*, 163.

48. Mooney, *Myths of the Cherokee*, 162–63. William Holland Thomas was the adopted son of Yonaguska.

49. Holmes, "Aboriginal Pottery," 143.

50. *Western North Carolina*, 40–42.

51. Holmes, "Aboriginal Pottery," 53–56; Fewkes, "Catawba Pottery-Making," 73.

52. *Designs in Pottery by the Bigmeat Family* (Cherokee, NC: Indian Arts and Crafts Board, 1979). Many of the Indian Arts and Crafts Board brochures are reprinted in Mollie Blankenship and Stephen Richmond, *Contemporary Artists and Craftsmen of the Eastern Band of Cherokee Indians: Promotional Exhibits, 1969–1985* (Cherokee, NC: Qualla Arts and Crafts Mutual, Inc., 1987). Joanne F. Vickers and Barbara L. Thomas, eds., *No More Frogs No More Princes: Women Making Creative Choices at Midlife* (Freedom, CA: Crossing Press, 1993), 34–35.

53. Fewkes, "Catawba Pottery-Making," 73.

54. Holmes, "Aboriginal Pottery," 49.

55. Ibid., 56, 71; Fewkes, "Catawba Pottery-Making," 96. Fewkes distinguished between "coils" and "fillets" in a process he called "segmental building," rather than the more common "coiling."

56. Harrington, "The Last of the Iroquois Potters," 222.

57. Brett H. Riggs, "Removal Period Cherokee Households in Southwestern North Carolina: Material Perspectives on Ethnicity and Cultural Differentiation" (dissertation, University of Tennessee-Knoxville, 1999), 288; Holmes, "Aboriginal Pottery," 53–56.

THE "LAST" CHEROKEE POTTER

58. Holmes, "Aboriginal Pottery," 49.

59. Harrington, "The Last of the Iroquois Potters," 223. Today there is a ridge bearing the Katalsta name in Swain County, North Carolina, but it is not known if this is the site of Katalsta's home. Thanks to the help of Hunter Library archivist George Frizzell, the author was able to locate the enrollment record for Iwi Katalsta. On it, her English name is listed as Eve Catolster. The form also includes her Cherokee name as E-wee Ga-to la sta. She was born December 1940.

60. Holmes, "Aboriginal Pottery," 73, 49; Harrington, "The Last of the Iroquois Potters," 225.

61. Brett H. Riggs and Christopher B. Rodning. "Cherokee Ceramic Traditions of Southwestern North Carolina, ca. A.D. 1400–2002: A Preface to 'The Last of the Iroquois Potters,'" *North Carolina Archaeology* 51 (2002), 37.

62. M.R. Harrington, "Catawba Potters and their Work," *American Anthropologist* 10 (1908), 406–07.

POTTERY FOR THE PUBLIC

63. *Jackson County Journal*, "Appalachian Ry. Is Now Completed," April 16, 1909.

64. Inscription on Woodrow Wilson Memorial Bridge marker in Prince George's County, Maryland, found at http://www.hmdb.org/marker. asp?marker=19756.

65. *Asheville Citizen*, "Colburn Sketches Past and Present of Cherokees," September 30, 1928; Henry M. Owl, "The Eastern Band of Cherokee Indians: Before and After the Removal" (thesis, University of North Carolina–Chapel Hill, 1929), 149.

66. Christina Taylor Beard-Moose, *Public Indians, Private Cherokees: Tourism and Tradition on Tribal Land* (Tuscaloosa: University of Alabama Press, 2009), 85, 144, 122. Lambert's quotations from Laurence French and Jim Hornbuckle, eds., *The Cherokee Perspective: Written by Eastern Cherokees* (Boone, NC: Appalachian Consortium Press, 1981), 143–45.

67. Fewkes, "Catawba Pottery-Making," 98; Mary Ulmer Chiltoskey, *Cherokee Fair & Festival: A History thru 1978* (Cherokee, NC: Cherokee Indian Festival Association, 1978), 7–8. The original spelling of Goingback Chiltoskey's name was Chiltoskie. Goingback is spelled several ways; he was colloquially known as "G.B."

68. *Ruralite*, "Indian Festival May be Held in Tourist Season," October 8, 1935; *New York Times*, "Cherokee Indian Festival near Asheville," July 3, 1938; *Cherokee Indian Fair and Folk Festival* (Cherokee, NC, 1935), 2; *33rd Annual Cherokee Indian Fair* (Cherokee, NC, 1950), 14. Several Cherokee Indian Fair program guides are available from http://craftrevival.wcu.edu.

69. *Smoky Mountain Indian Trail*, untitled news clipping, April 25, 1934; *Asheville Citizen*, "Cherokee Plan Puts Stress on Crafts," June 17, 1939.

70. Sharlotte Neely Williams, *The Role of Formal Education among the Eastern Cherokee Indians: 1880–1917* (Chapel Hill: University of North Carolina, 1971), 8; *Asheville Citizen*, "Cherokee Plan"; John Parris, "Crusade to Revive Cherokee Weaving Art Got Its Start 27 Years Ago," *Asheville Citizen*, May 3, 1957; Gertrude Flanagan interview.

71. *Asheville Citizen*, "Cherokee Plan."

72. Stites, "Kilns for the Cherokee," 2-10; *New York Times*, "Carolina Crafts Thrive: Mountain People Revive their Native Arts and Handwork on Large Scale," April 17, 1938, 153.

73. Stites, "Kilns for the Cherokee," 4, 9, 10; *33rd Annual Cherokee Indian Fair*, 14; Gertrude Flanagan interview; Fewkes, "Catawba Pottery-Making," 101; Leonard Bloom, "A Measure of Conservatism," *American Anthropologist* 47 (1945): 630–35.

74. U.S. Department of Interior Indian Arts and Crafts Board, "Indian Arts and Crafts Act of 1935," http://www.doi.gov/iacb/iaca35.html. For a full discussion on IACB, see Robert Fay Schrader, *Indian Arts and Crafts Board* (Albuquerque: University of New Mexico Press, 1983). Frederic H. Douglas and Rene d'Harnoncourt, *Indian Art of the United States* (New York: Museum of Modern Art, 1941); Rene d'Harnoncourt, "All-American Art," *Art Digest* 15 (January 1, 1941), 17.

75. *Smoky Mountain Indian Trail*, "Chief Jarrett Blythe," May 30, 1934; Stites, "Kilns for the Cherokee," 2–3.

76. Untitled, undated minutes of meeting held by Joe Jennings on August 6, possibly 1944 or 1945; Undated survey of Cherokee artisans by community and discipline in the archives of Qualla Arts and Crafts Mutual, Inc. (Author's tally reflects a count of names, but some people were listed under more than one craft); "Arts and Crafts Meeting," October 11, 1945; "Meeting-Qualla Hall," August 9, 1945; "Arts and Crafts Meeting," November 18, 1945/1946. Meeting minutes are in Qualla Arts and Crafts Mutual archive.

77. Gertrude Flanagan interview; Parris, "Crusade to Revive"; "Arts and Crafts Meeting," October 11, 1945.

78. "Arts and Crafts Meeting," October 15, 1945; "Arts and Crafts Meeting," November 29, 1945; "Arts and Crafts Meeting," December 6, 1945; "Arts and Crafts Meeting," March 25, 1946; "Arts and Crafts Meeting," August 23, 1946. Disciplines represented on the committee included "beadwork, dolls, weaving, baskets, woodcrafts, metal work, and miscellaneous."

79. "Arts and Crafts Meeting," March 25, 1946; Gertrude Flanagan interview; "Arts and Crafts Meeting," February 27, 1946; "Arts and Crafts Meeting," August 23, 1946.

80. Gertrude Flanagan interview; "The Qualla Arts and Crafts," *Indian Trader* (September 1976), 18–19.

POTTERY IN THE TWENTIETH CENTURY

81. Vickers and Thomas, *No More Frogs*, 33.

82. *Designs in Pottery*.

83. Ibid.; Vickers and Thomas, *No More Frogs*, 35.

84. Joel Queen, "Integrating the Symbolic Past to Shape the Future of Cherokee Pottery" (thesis, Western Carolina University, 2009), 18.

85. *Designs in Pottery*.

86. Ibid.

87. Vickers and Thomas, *No More Frogs*, 34–35; *Designs in Pottery*.

88. Indian Arts and Crafts Board, *Bigmeat Family*; Vickers and Thomas, *No More Frogs*, 34–37; *Documentary of Six Cherokee Artists* (Cherokee, NC: Indian Arts and Crafts Board, 1976).

89. Ibid.

90. Stites, "Kilns for the Cherokee," 6; Cora Wahnetah recorded interview, National Archives and Records Administration, Southeastern Division, Atlanta, Georgia; *Pottery by Cora Wahnetah* (Cherokee, NC: Indian Arts and Crafts Board, 1971).

91. Cora Wahnetah interview; T.M.N. Lewis and Madeline Kneberg, "Oconaluftee Indian Village: An Interpretation of a Cherokee Community of 1950," 1954, Cherokee Historical Association, Museum of the Cherokee Indian; Cora Wahnetah interview.

92. Cora Wahnetah interview.

93. Ibid.

94. Ibid. Her name is sometimes spelled Wahyahneetah.

95. Edith Welch Bradley interview.

96. Collins and Cheek. *Foxfire 12*, 399, 404–05.

97. "Amanda Swimmer," *North Carolina Folklore Journal* 44 (1997), 95; Juanita Hughes. *Wind Spirit: An Exhibition of Cherokee Arts and Crafts* (Cherokee, NC: Museum of the Cherokee Indian and Qualla Arts and Crafts Mutual, 1982), 27; Collins and Cheek, *Foxfire 12*, 407–08.

98. Collins and Cheek, *Foxfire 12*, 407–08.

99. Ibid., 409–10.

100. *Cherokee Potters Guild* (Cherokee, NC: Cherokee Potters Guild, 2004); Cherokee Heritage Center, *People of One Fire*, 15.

BIBLIOGRAPHY

BOOKS

Bartram, William. *Travels through North and South Carolina, Georgia, East and West Florida*. London, 1792. Reprint, Savannah, GA: Beehive Press, 1973.

Beard-Moose, Christina Taylor. *Public Indians, Private Cherokees: Tourism and Tradition on Tribal Land*. Tuscaloosa: University of Alabama Press, 2009.

Blankenship, Mollie, and Stephen Richmond. *Contemporary Artists and Craftsmen of the Eastern Band of Cherokee Indians: Promotional Exhibits, 1969–1985*. Cherokee, NC: Qualla Arts and Crafts Mutual, Inc., 1987.

Chambers, Erve. *Tourism and Culture: An Applied Perspective*. Albany: State University of New York Press, 1997.

Chapman, Jefferson. *Tellico Archaeology: 12,000 Years of Native American History*. Knoxville: University of Tennessee Press, 1995.

Cherokee Heritage Center. *People of One Fire*. Tahlequah, OK: Cherokee Heritage Press, 2007.

Chiltoskey, Mary Ulmer. *Cherokee Fair & Festival: A History Thru 1978*. Cherokee, NC: Cherokee Indian Festival Association, 1978.

Collins, Kaye Carver, and Angie Cheek, eds. *Foxfire 12*. New York: Anchor Books, 2004.

Conley, Robert J. *Cherokee Nation*. Albuquerque: University of New Mexico Press, 2005.

Denson, Andrew. *Demanding the Cherokee Nation: Indian Autonomy and American Culture, 1830–1900.* Lincoln: University of Nebraska Press, 2004.

Dickens, Roy S., Jr. *Cherokee Prehistory: The Pisgah Phase in the Appalachian Summit Region.* Knoxville: University of Tennessee Press, 1976.

Douglas, Frederic H., and Rene D'Harnoncourt. *Indian Art of the United States.* New York: Museum of Modern Art, 1941.

Duncan, Barbara R., and Davy Arch, eds. *Living Stories of the Cherokee.* Chapel Hill: University of North Carolina Press, 1998.

Duncan, Barbara R., and Brett H. Riggs, eds. *Cherokee Heritage Trails Guidebook.* Chapel Hill: University of North Carolina Press, 2003.

Eaton, Allen. *Handicrafts of the Southern Highlands.* New York: Russell Sage, 1937.

Ethridge, Robbie, and Charles Hudson, eds. *The Transformation of the Southeastern Indians, 1540–1760.* Oxford: University of Mississippi Press, 2008.

Fariello, M. Anna. *Cherokee Basketry: From the Hands of Our Elders.* Charleston, SC: The History Press, 2009.

Fariello, M. Anna, and Paula Owen, eds. *Objects and Meaning: New Perspectives on Art and Craft.* Lanham MD, Scarecrow Press, 2003.

Finger, John R. *Cherokee Americans: The Eastern Band of Cherokees in the Twentieth Century.* Lincoln: University of Nebraska Press, 1991.

French, Laurence, and Jim Hornbuckle, eds. *The Cherokee Perspective: Written by Eastern Cherokees.* Boone, NC: Appalachian Consortium Press, 1981.

Gilbert, William Harlen. *The Eastern Cherokees.* Washington, D.C.: Smithsonian Institution, 1943. Reprint, New York: AMS Press, 1978.

Hally, David J. *Ocmulgee Archaeology 1936–1986.* Athens: University of Georgia Press, 1994.

Holmes, W.H. "Aboriginal Pottery of the Eastern United States." *Twentieth Annual Report of the Bureau of American Ethnology.* Washington, D.C.: Government Printing Office, 1903.

Hughes, Juanita. *Wind Spirit: An Exhibition of Cherokee Arts and Crafts.* Cherokee, NC: Museum of the Cherokee Indian and Qualla Arts and Crafts Mutual, 1982.

Keel, Bennie C. *Cherokee Archaeology: A Study of the Appalachian Summit.* Knoxville: University of Tennessee Press, 1976.

Leftwich, Rodney L. *Arts and Crafts of the Cherokee.* Cherokee, NC: Cherokee Publications, 1970.

Mooney, James. *Myths of the Cherokee.* Washington, D.C.: Government Printing Office, 1897–1898. Reprint, New York: Johnson Reprint Company, 1970.

Museum of the American Indian. *Naked Clay: 3000 Years of Unadorned Pottery of the American Indian*. New York: Heye Foundation, 1972.

Peterson, Susan. *Pottery by American Indian Women: The Legacy of Generations.* New York: Abbeville Press, 1997.

Power, Susan C. *Art of the Cherokee.* Athens: University of Georgia Press, 2007.

Purdue, Theda. *Cherokee Women: Gender and Culture Change: 1700–1835.* Lincoln, University of Nebraska Press, 1998.

Rice, Prudence M. *Pottery Analysis: A Sourcebook.* Chicago, IL: University of Chicago Press, 1987.

Schrader, Robert Fay. *Indian Arts and Crafts Board.* Albuquerque: University of New Mexico Press, 1983.

Sinopoli, Carla M. *Approaches to Archaeological Ceramics.* New York: Plenum Press, 1991.

Timberlake, Henry. *Memoirs: 1756–1765.* London, 1767. Reprint, Marietta, GA: Continental Book, 1948.

Vickers, Joanne F., and Barbara L. Thomas, eds. *No More Frogs No More Princes: Women Making Creative Choices at Midlife.* Freedom, CA: Crossing Press, 1993.

Ward, H. Trawick, and R.P. Stephen Davis Jr. *Time Before History.* Chapel Hill: University of North Carolina Press, 1999.

Williams, Samuel Cole, ed., *Adair's History of the American Indians.* New York: Promontory Press, 1930.

Williams, Sharlotte Neely. *The Role of Formal Education among the Eastern Cherokee Indians: 1880–1917.* Chapel Hill: University of North Carolina, 1971.

Articles

"Amanda Swimmer." *North Carolina Folklore Journal* 44 (1997), 95–96.

Anderson, William L. "Cherokee Clay, from Duché to Wedgwood: The Journal of Thomas Griffiths, 1767–1768." *North Carolina Historical Review* 63, no. 4 (1986), 477–510.

Asheville Citizen. "Cherokee Plan Puts Stress on Crafts," June 17, 1939.

———. "Colburn Sketches Past and Present of Cherokees," September 30, 1928.

Atlanta Constitution. "American Indian Exhibition Staged This Week at Southeastern Fair," September 30, 1934.

———. "Four Indian Villages, Seminole, Pueblo, Navajo, Cherokee Show Varied Types of Construction at Southeastern Fair" (Sept. 23, 1934).

———. "Indians of Twelve Tribes Reveal Artistry in Varied Handicrafts Practiced at Fair," October 5, 1934.

Bloom, Leonard. "A Measure of Conservatism." *American Anthropologist* 47 (1945), 630–35.

Blumer, Thomas J. "Catawba Influences on the Modern Cherokee Tradition." *Appalachian Journal* 14, no. 2 (Winter 1987), 153–73.

———. "Rebecca Youngbird: An Independent Cherokee Potter." *Journal of Cherokee Studies* 5 (1980), 41–49.

Curtis, Natalie. "Our Native Craftsmen." *Southern Workman* 48 (August 1919), 389–96.

D'Harnoncourt, Rene. "All-American Art." *Art Digest* 15 (January 1, 1941), 17.

Fewkes, Vladimir J. "Catawba Pottery-Making with Notes on Pamunkey Pottery-Making, and Coiling." *Proceedings of the American Philosophical Society* 88 (July 7 1944), 69–124.

Gloyne, Dinah Smoker. "Cherokee Craftsmen." *Mountain Life and Work* 26 (1951), 16.

Harrington, M.R. "Catawba Potters and their Work." *American Anthropologist* 10 (1908): 399–407.

———. *Cherokee and Earlier Remains on Upper Tennessee River.* New York: Museum of the American Indian/Heye Foundation, 1922.

———. "The Last of the Iroquois Potters." *Museum Bulletin* 133 (1909), 222–27. Reprinted in *North Carolina Archaeology* 51 (2002): 56–57.

Jackson County Journal, "Appalachian Ry. Is Now Completed," April 16, 1909.

Kimball, Larry R., Thomas R. Whyte and Gary D. Crites. "The Biltmore Mound and Hopewellian Mound Use in the Southern Appalachians." *Southeastern Archaeology* (2010), 44–58.

King, Duane H. "Vessel Morphology of Eighteenth Century Overhill Ceramics." *Journal of Cherokee Studies* 2 (1977), 154–69.

New York Times. "Carolina Crafts Thrive: Mountain People Revive their Native Arts and Handwork on Large Scale," April 17, 1938.

———. "Cherokee Indian Festival near Asheville," July 3, 1938.

———. "In the 'Land of the Sky,'" April 7, 1895.

Owl, Henry M. "Catawba Indian Woman Inspires Cherokees." *Charlotte Observer,* January 12, 1930.

Parris, John. "Crusade to Revive Cherokee Weaving Art Got Its Start 27 Years Ago." *Asheville Citizen*, May 3, 1957.

Riggs, Brett H., and Christopher B. Rodning. "Cherokee Ceramic Traditions of Southwestern North Carolina, ca. A.D. 1400–2002: A Preface to 'The Last of the Iroquois Potters.'" *North Carolina Archaeology* 51 (2002), 34–51.

Rodning, Christopher B. "Temporal Variation in Qualla Pottery." *North Carolina Archaeology* 57 (2008).

Ruralite, "Indian Festival May be Held in Tourist Season," October 8, 1935.

Smoky Mountain Indian Trail (Cherokee, N.C.), April 25, 1934.

OTHER WORKS CONSULTED

Amanda Swimmer, Cherokee Potter, Qualla Arts and Crafts Mutual, Inc., circa 1982.

"Arts and Crafts Meeting." Minutes, Qualla Arts and Crafts Mutual archive.

Cherokee Indian Fair. Programs, http://craftrevival.wcu.edu.

Cherokee Potters Guild. Cherokee, NC: Cherokee Potters Guild, 2004.

Cora Wahnetah recorded interview, National Archives and Records Administration, Atlanta, Georgia.

Designs in Pottery by the Bigmeat Family. Cherokee, NC: Indian Arts and Crafts Board, 1979.

Documentary of Six Cherokee Artists. Cherokee, NC: Indian Arts and Crafts Board, 1976.

Edith Welch Brady recorded interview. 1979, Blumer Collection, University of South Carolina–Lancaster.

Gertrude Flanagan recorded interview, National Archives and Records Administration, Atlanta, Georgia.

"Indian Boarding Schools," *Indian Country Diaries*, National Public Radio, http://www.pbs.org/indiancountry/history/boarding2.html.

Lewis, T.M.N., and Madeline Kneberg. "Oconaluftee Indian Village: An Interpretation of a Cherokee Community of 1950." 1954. Cherokee Historical Association, Museum of the Cherokee Indian.

Owl, Henry M. "The Eastern Band of Cherokee Indians: Before and After the Removal." Thesis, University of North Carolina–Chapel Hill, 1929.

Pottery by Cora Wahnetah. Cherokee, NC: Indian Arts and Crafts Board, 1971.

Queen, Joel. "Integrating the Symbolic Past to Shape the Future of Cherokee Pottery." Thesis, Western Carolina University, 2009.

Rebecca Youngbird interview. 1979, Blumer Collection, University of South Carolina–Lancaster.

Riggs, Brett H. "Removal Period Cherokee Households in Southwestern North Carolina: Material Perspectives on Ethnicity and Cultural Differentiation." PhD diss., University of Tennessee–Knoxville, 1999.

Southern Mountain Handicraft Guild, "Minutes of the Annual Meeting," April 1, 1932, http://craftrevival.wcu.edu.

Stites, Raymond S. "Kilns for the Cherokee." 1935, National Archives and Records Administration, Southeastern Division, Atlanta, Georgia.

U.S. Department of Interior Indian Arts and Crafts Board, "Indian Arts and Crafts Act of 1935," http://www.doi.gov/iacb/iaca35.html.

ABOUT THE AUTHOR

Curator and scholar, Anna Fariello is associate professor at Western Carolina University's Hunter Library, where she is building digital collections focused on the region's material culture. She is a former research fellow with the Smithsonian American Art Museum and former field researcher for the Smithsonian Folklife Center. Fariello traveled to Central America as a senior Fulbright fellow and serves as museology specialist for the U.S. Fulbright Commission. The recipient of the 2010 Brown Hudson Award from the North Carolina Folklore Society, she currently serves on the board of the World Craft Council. She is the author of several book chapters, fifty articles and conference presentations and curator of over forty exhibitions. Among her publications, she is author of *Cherokee Basketry: From the Hands of our Elders* (2009) and coauthor of the textbook, *Objects & Meaning: New Perspectives on Art and Craft* (2003).

Visit us at
www.historypress.net